Nicolas A.

—

Dean Daderko
& Elaine Reichek

in conversation

Nicolas A. Moufarrege

———

Dean Daderko & Elaine Reichek

in conversation

Visual AIDS, New York

I WANT TO DRAW. I WANT TO PAINT. I HAVE SOMETHING TO SAY. TO EVERYONE AND AS MANY AS I POSSIBLY CAN. I AM DOING IT ON THE STREETS. I AM DOING IT IN MY ROOM, I AM DOING IT UNDERGROUND. I AM DOING IT ON THE TRAINS, ON THE BILLBOARDS, IN THE MAIL. THE PALACES ARE FULL BUT NEW ONES ARE BEING BUILT: IN THE NIGHTCLUBS AND IN THE BATHROOMS. I WILL WORK WITH AND ON WHATEVER I CAN LAY MY HANDS ON. I WILL CARVE ON A TREE OR ON A ROCK, I WILL USE PAINT, CHALK, OR ANY STICK THAT LEAVES A MARK. I WILL DRAW PICTURES AND COLOR THEM. I WILL WRITE WORDS, IN MY LANGUAGE AND IN YOURS. I WILL BUILD TOYS. I WILL MAKE SOUNDS AND INSTRUMENTS THAT MAKE SOUNDS. I WILL RAP AND I WILL SING AND I WILL DANCE TO IT ALL. I WANT YOU TO KNOW MY NAME. I WANT YOU TO RECOGNIZE MY SIGN.

FROM: "ANOTHER WAVE, STILL MORE SAVAGELY THAN THE FIRST: LOWER EAST SIDE, 1982," *ARTS MAGAZINE*, SEPTEMBER 1982

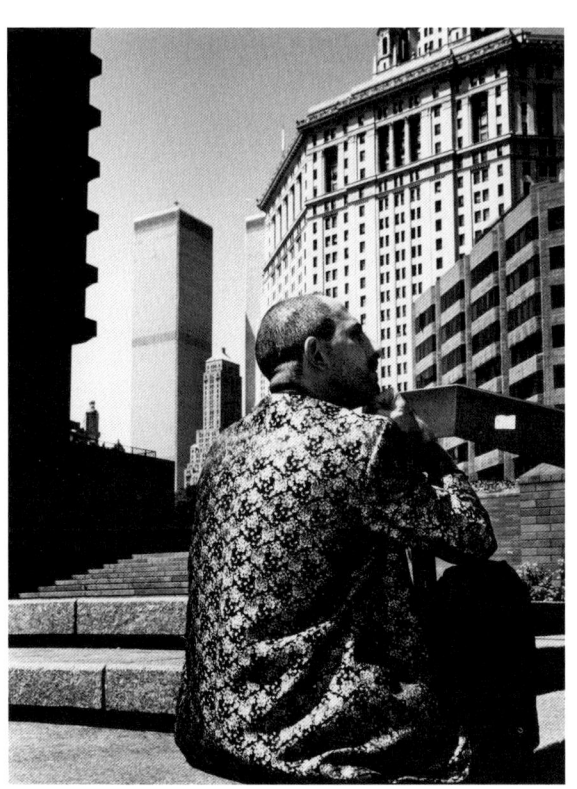

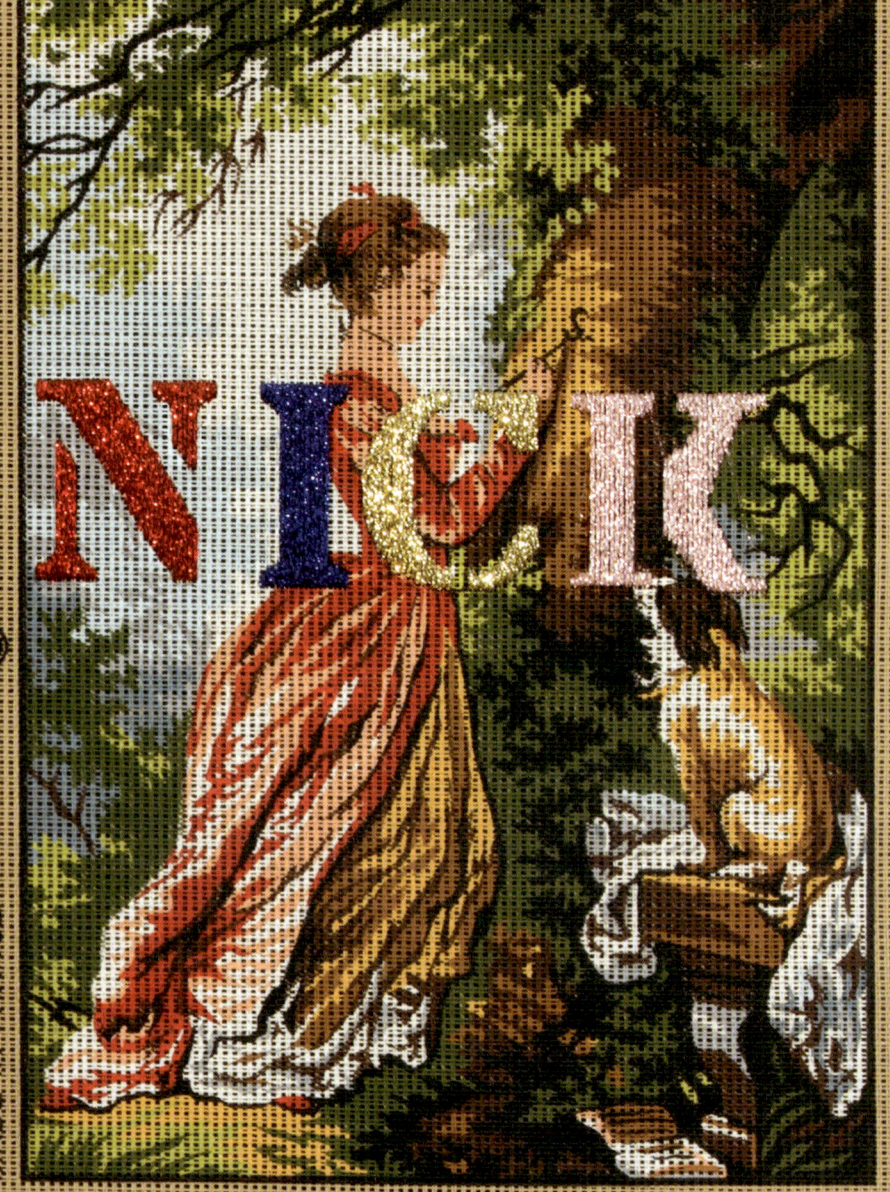

Contents

8 **Preface**
Nelson Santos

11 **Foreword**
LJ Roberts

15 **Dean Daderko & Elaine Reichek in conversation**

49 **Selected Writings by Nicolas A. Moufarrege**

62 **His Embroidery Story**
Sur Rodney (Sur)

65 **Biography**

67 **Bibliography**

70 **Contributors**

Title unknown (detail), 1985. Thread on needlepoint canvas and fabric, 51 x 38 inches.
Collection of Nabil A. Moufarrej.

Preface

In this issue of DUETS, curator Dean Daderko and artist Elaine Reichek share an insightful conversation about artist, writer, and curator Nicolas Moufarrege (1947–1985). As an art critic, Moufarrege is often credited for putting the East Village on the map, but his "idiosyncratic embroidered paintings," as *New York Times* art critic Roberta Smith asserted in 1987, "[confirm] that he deserves to be remembered most of all for his art."

Nabil Moufarrej has said his brother's love of and facility with embroidery started out of a need to patch a hole in his jeans; by the time he was finished, the entire leg of his bell-bottom jeans was embellished with surreal flowers and butterflies. Soon after, he took to making tapestries and beautifully elaborate embroidered works.

The AIDS Quilt was conceived in 1987, the same year ACT-UP was formed, but sadly Nicolas Moufarrege did not see either of those. He died at age thirty-seven on June 4, 1985—it would be another three months before then–United States President Ronald Reagan would publicly utter the word *AIDS*. By early 1985, there would be 7,239 reported cases of AIDS in the US, and 5,596 deaths, though for many in the art world, Moufarrege's death was an early awakening. David Wojnarowicz, who was Moufarrege's good friend, visited him in the hospital, and as Cynthia Carr describes in *Fire in the Belly: The Life and Times of David Wojnarowicz*, "This would have been his first look at what it could mean to be sick with AIDS."

I imagine if Moufarrege had lived long enough, he would have created beautifully heartbreaking embroidered panels for the quilt,

but it would be another eleven years after his passing until the "cocktail," or HAART (highly-active antiretroviral therapy), would even become available. This publication, thirty-one years after Moufarrege's premature death, humbly attempts to share his legacy, give his work the recognition it deserves, and keep his memory alive.

Visual AIDS present DUETS as a way to honor the work of artists with HIV/AIDS and preserve the artistic contributions of the AIDS pandemic. Founded in 1988, Visual AIDS continues to be the only contemporary arts organization fully committed to raising AIDS awareness and creating dialogue around HIV issues today, by producing and presenting visual art projects, exhibitions, public forums and publications—while assisting artists living with HIV/AIDS.

Thank you to Dean Daderko, Elaine Reichek, Sur Rodney (Sur), and LJ Roberts for their dedication and thoughtful contributions. My most sincere gratitude to the Estate of Nicolas Moufarrege for all of their support, with a special thanks to Nabil Moufarrej and Gulnar (Nouna) Mufarrij.

I'd also like to thank Bradley and Holly Cole, Michèle C. Cone, Timothy Cone, Nabil Moufarrej, Laura Skoler, Sur Rodney (Sur), George Waterman III, and Pavel Zoubok for generously loaning their work and providing images for this publication; Cynthia Carr, Ryan Duffin, Jean Foos, Christine Lombard, Mary-Ann Monforton, Asher Mones, Chuck Nanney, Kris Nuzzi, and Bill Stelling for sharing their knowledge and assisting with research; and my Visual AIDS colleagues, Associate Director Esther McGowan and Programs Director Alex Fialho, for all their hard work and dedication to make this and all of Visual AIDS projects possible.

Nelson Santos
Executive Director, Visual AIDS

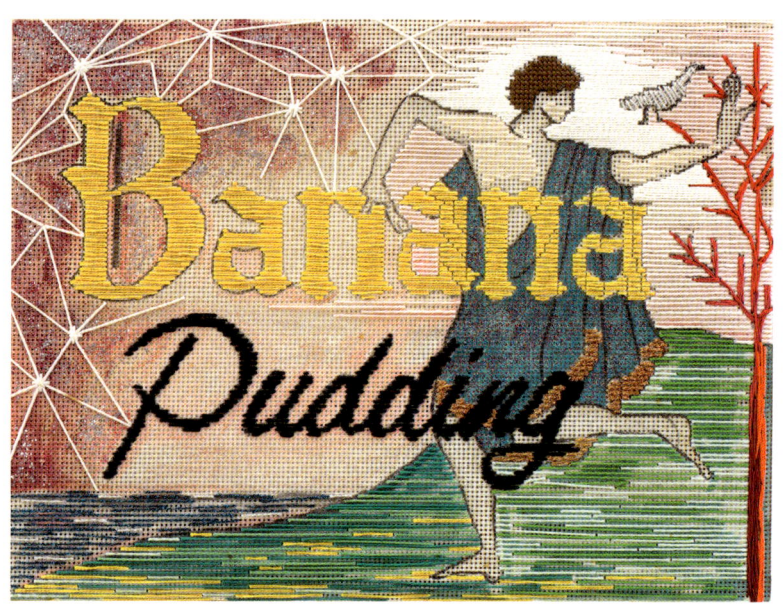

Banana Pudding, c. 1982. Thread and paint on needlepoint canvas and mixed media, 10 x 12 inches. Collection of Laura Skoler

Foreword
LJ Roberts

"Do you think being at home with AIDS is political?" read the slide projected onto the wall at the New HIV Discourses conference that I attended in the fall of 2015 at the University of Arizona. I had gone to the conference not only to meet up with friends but also to hear Alexandra Juhasz speak. Juhasz was a founder of the WAVE (Women's AIDS Video Enterprise) Project. WAVE was a collective of women, mostly women of color, who made videos about their experiences of activism and caregiving in the early 1990s during the height of the epidemic.

The slide struck me, reminding me of a small embroidered piece by the late Nicolas Moufarrege. I had seen it in the exhibition "Not Over: 25 Years of Visual AIDS" at La MaMa Galleria (2013). I recalled standing in the exhibition with Sur Rodney (Sur), one of its curators, staring with confused curiosity at the glittery and campy work installed in minimal salon style on the back wall of the gallery.

"Banana Pudding," read its text. "Banana Pudding? What's the reference?" I asked Sur. He explained: When men were together in hospice dying of AIDS, one of the favorite desserts they ingested was banana pudding, but *banana pudding* was also a term for the ejaculate produced by a good blow job.

I smiled, acknowledging the humor of the piece—a cheeky humor, filled with politics, celebration, and sadness. Banana pudding brought a confluence of nourishment, impending death, and sexuality into the same room. I like to think that both kinds of banana pudding were there as physical nourishment, as acts of resistance, and as part of an effort to survive psychically, sexually, and emotionally. Within the complexity of the raging epidemic, both banana puddings served to self-preserve and care for others.

What could be more passive than pudding? At first glance, Moufarrege's *Banana Pudding* could be seen as benign, with its glitter and its rainbows. But the pudding, spooned into the mouths of those men, was made from a phallic fruit that was pulverized. That's more than a metaphor, that's an indictment.

I see tactics as much as temporality pulsing through the textile work of Moufarrege. He mixed camp and domesticity—nodding to the queer stereotypes of drag. That fusion recognizes and defiantly owns what I imagine was an often-ridiculed masculinity that was pinned onto gay men at the time.

In their conversation for this edition of DUETS, artist Elaine Reichek and curator Dean Daderko speak of the power of relationships between gay men and women, straight and queer; the sharing of love, care, artistic collaboration, and creative community. Elaine and Nicolas shared a medium—embroidery—and an extensive knowledge of art history. While Elaine was busting the canon open, shifting concepts of mark making using thread and knitting, Nicolas was infusing his work with queer politics, nuanced history, and feminism. Of course, these strategies are bedfellows, and Moufarrege's and Reichek's ways of working were not only ahead of their time but also timely artistic and political interventions.

In the midst of their artistic friendship and navigation of a wild New York City, Nicolas developed AIDS, and his health declined rapidly. Horrified by the treatment he received when he was finally admitted into a hospital in the Bronx after being turned away by many in Manhattan, Elaine and others fought to ensure he was physically cared for, pairing that fight with one against the stigma that pervaded the epidemic; they fought for their friend's body and his emotional well-being.

When we ask the question "Do you think being at home with AIDS is political?" we know the answer is yes. And we know that it surely is in the hospital as well. We know that AIDS is political everywhere.

Dean talks here about "Side X Side" a show he had curated in summer 2008. Dean stated that he "wanted to bring women I knew as caregivers to the table" because he felt that a lot of them had been "edged out of the conversation." He was also "acutely aware that the men in the show were no longer with us" and wanted to include "works made over the arcs of the artists' careers—some of them cut too short."

Nicolas's work was included in Dean's show, along with the work of Kate Huh, who also moved to the East Village in the 1980s. In 2015, Kate and I embarked on a long-term collaboration combining collage and embroidery: mediums Nicolas frequently used. Though Kate and I are of different generations, we, like Elaine and Dean, share a social experience. This kinship is a key theme of the work. And so as we watch New York City change rapidly, the legacy of gay men, women, and trans people whose friendships merge with creative output carries on. Together we create and care for one another to survive, to cope, to thrive, to be with one another in our homes and to help one another be at home in the world.

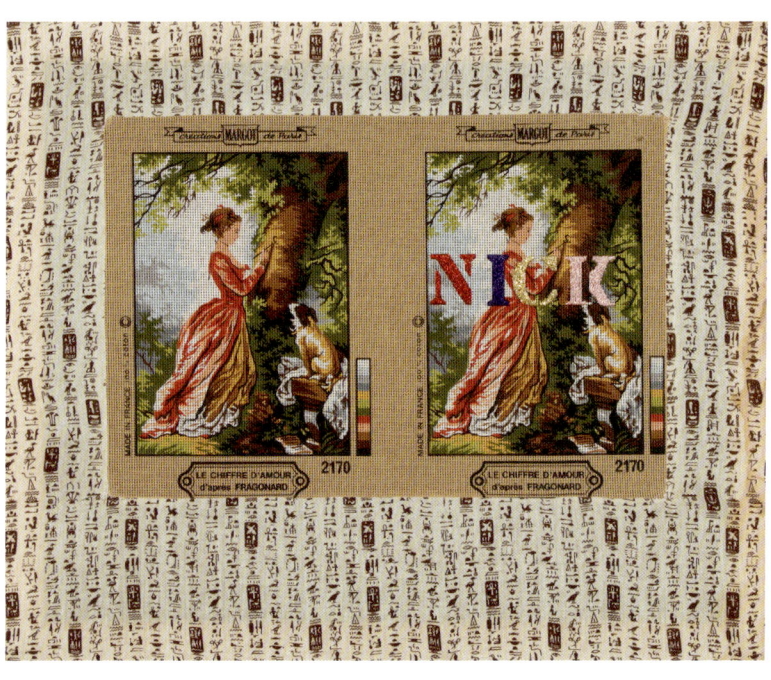

Title unknown (detail), 1985. Thread on needlepoint canvas and fabric, 51 x 38 inches.
Collection of Nabil A. Moufarrej

Dean Daderko & Elaine Reichek in conversation

Dean Daderko: The first time I ever saw Nicolas's work was in "The Downtown Show" at the Grey Art Gallery. I remember walking downstairs into the basement and right at the bottom of the stairs on a wall painted black was a small, embroidered painting; there was a brooch attached to its surface and it had a psychedelic, mystical demeanor. I loved it and had never heard of the artist who made it. Since I like discoveries like this, I started researching and asking around and found out very quickly that Nicolas was no longer with us but that he had had a huge influence on the East Village art scene. I found out he was a close friend of Peter Hujar, David Wojnarowicz, and Chuck Nanney, among others, and that his essay "Another Wave, Still More Savagely Than the First: Lower East Side, 1982" really put the East Village art scene on the map.

Elaine Reichek: Nicky was a kind of cultural poet of the East Village.

Dean: From what I understand, he first came to America in 1968 on a Fulbright grant to go to Harvard, where he studied chemistry.

Elaine: He was Lebanese, born in Egypt. The family had left Egypt for Beirut, where they lived in a high-rise apartment in an area that was relatively safe and were spared the more severe bombing. Nicolas left Lebanon in the mid-1970s and settled in Paris, where he acquired an affection for French literature and culture. He was a friend of Pierre Restany, who was a big influence.

Dean: What were your first impressions of Nicolas?

Elaine: When I was eighteen or so I read a book called *À rebours*

(*Against the Grain*). Back then it was sort of a cult novel, by Joris-Karl Huysmans, a realist writer whose disappointment with Zola made him turn to the Decadents—Flaubert, Mallarmé, Verlaine, Baudelaire. I thought of the book when I first visited Nicky in his apartment, because he had created a specific kind of aesthetic vehicle for the "exotic," using quotation and juxtaposition to create a particular ambience. I guess there's not a direct parallel between the main character in the novel and Nicky, but there *is* something. Nicky spoke three languages fluently and was extremely sophisticated in his taste for literature. Translation, which has been central to my own work, was also part of his.

Dean: I remember seeing one of his beautiful embroidered works—on one side was the cartoon character the Silver Surfer next to a statement written in Arabic. A friend translated it for me. It read, "My father taught me Arabic calligraphy." I was kind of surprised; at first I was expecting something more philosophical, but instead found it intensely witty. It is not the only instance of how Nicolas intermingled text with images of superheroes, cartoon characters, and cultural icons like Santa Claus.

Elaine: Saint Nicolas! He was so witty and had such an ear for language.

Dean: What do you remember about his time in New York?

Elaine: When he came to New York in 1981, Nicolas was bowled over. He found a like-minded community here, for which he was truly grateful. He told me he could never imagine the degree of sexual freedom and lack of moralizing. He was thrilled!

The East Village was historically an immigrant community. Much of the housing in the neighborhood was built for dense dwelling—so you had the rich and the poor cheek by jowl. I'm from New York, and for me it's always been a city of immigrants, where everybody is welcome. If you come to New York and you want to be part of something,

you can be. But it was also a specific time in New York's history, a time of enormous appetite and energy. Things were changing. Warhol's legacy had opened up the art world to people from other places. It was the early eighties, when the clubs accommodated everybody. People might say, "Put up or shut up" or "Tell me who you are and why you're here," in the rudest, most frank way, but if they thought you had something good to say, you'd get a seat at the table. There was a whole city full of starry-eyed people, where there was too much money, too many drugs, too much everything. It was a really interesting time, but it was also a very sad time. There was even sadness in the excess. It was a very bright star that burned itself out quickly . . . It had a fin-de-siècle sadness.

Dean: I wonder if the plurality of New York at that time isn't what enabled a postmodern aesthetic so conducive to appropriation and pastiche?

Elaine: Nicolas's own personal history comes out in his own approach to pastiche. I think globalism was part of his interdisciplinary practice. He and I talked about the global discourse on textiles, for instance. He was really looking a lot at textiles and carpets. We did not talk about embroidery in terms of Greenbergian flatness. I was interested in the idea of piercing the support—but that was not part of Nicky's discourse. Nicky loved Pop.

Dean: Clearly, yes. But his work also incorporates a sensibility that's less Pop and more about ornament, surface, and pattern. It's Pop *and* classical. This *and* that.

Elaine: Nicky had a love of embellishment and gold and richness.

Dean: The embellishment, I imagine, also came out of a kind of love for Islamic tile work, and classical, rational structures like the golden rectangle. Nicolas's work amalgamates Eastern and Western art

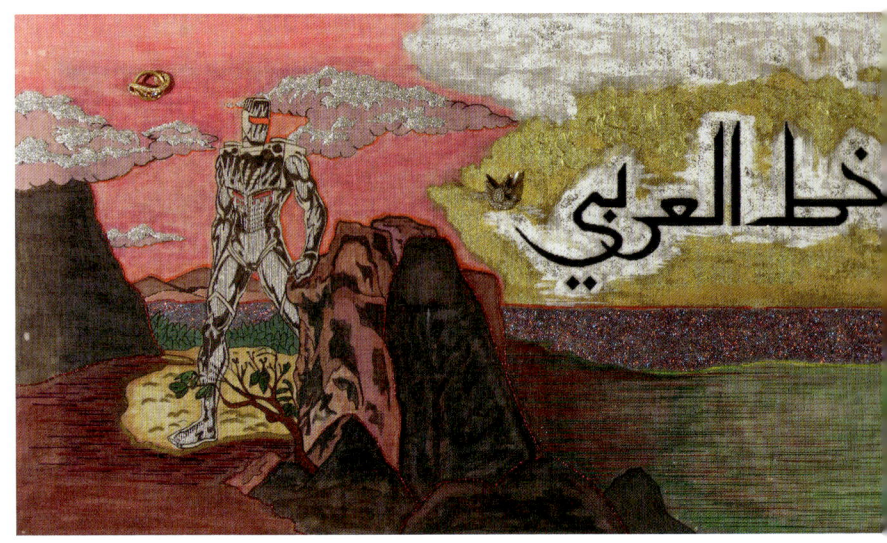

Top: *The Truth about John the Baptist*, 1983. Thread, glitter, brooches, and paint on needlepoint canvas, 19¾ x 72 inches. Collection of Nabil A. Moufarrej

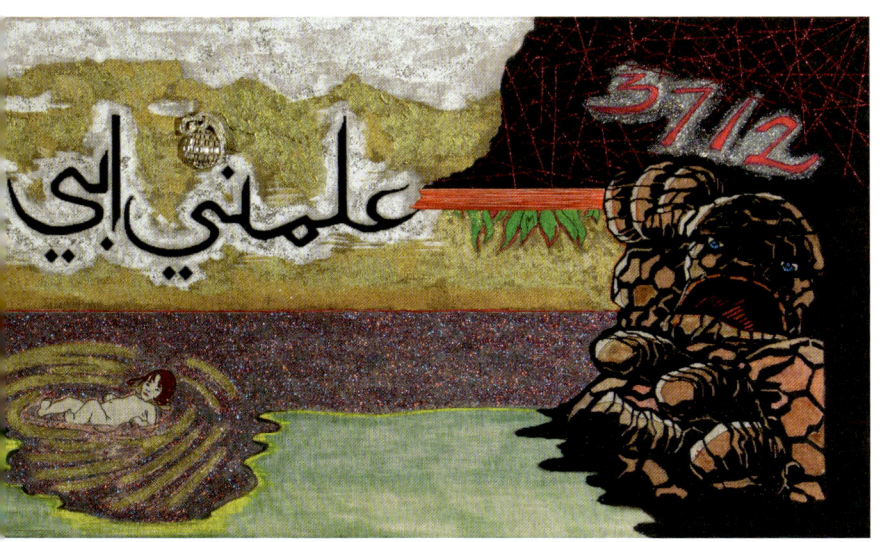

Bottom: *The Love Potion*, 1983. Thread, glitter, and paint on needlepoint canvas, 17⅞ x 54⅛ inches. Collection of Nabil A. Moufarrej

histories. His juxtapositions—say, of a Lichtenstein-like figure and a Hokusai wave—were created in sophisticated ways. There's friction between the parts; they jostle against each other. You see unexpected things push up against each other in his work.

Elaine: There is all this information—multicultural information. His "painting by numbers" is so fabulous in its reference to his own tracings and pastiche. And while Nicolas had an ethnological or sociological interest in jewels and embellishments, and he loved them personally, it was also part of an East Village aesthetic. He had an immediate context for his love of ornament—in the East Village at this time Rhonda Zwillinger was wielding her hot-glue gun and Arch Connelly was using every kind of glittery or shiny material. It was a really good scene! The East Village was full of people making wonderful work.

Dean: There was also a sense of social responsibility . . .

Elaine: That's just part of being aware that New York is a city of struggle. When did you come to the city?

Dean: I moved to New York in 1993 and soon after began to meet some of the people I think of as my queer family—Nancy Brooks Brody, Joy Episalla, Zoe Leonard, and Carrie Yamaoka among them—who were a generation ahead of me. I also recognized how few male role models I had in this group. I very quickly came to understand the decimation wrought by AIDS. Younger artists today are inspired by artwork and activist models created by these people in the eighties—a time we can still see as aesthetically exciting and expansive—but because so many of these folks are no longer with us, the history can easily get lost. It's silenced. And this devastation is still an emotional subject for people who lost their closest friends.

Elaine: Yes, I understand—the mystery of the missing generation.

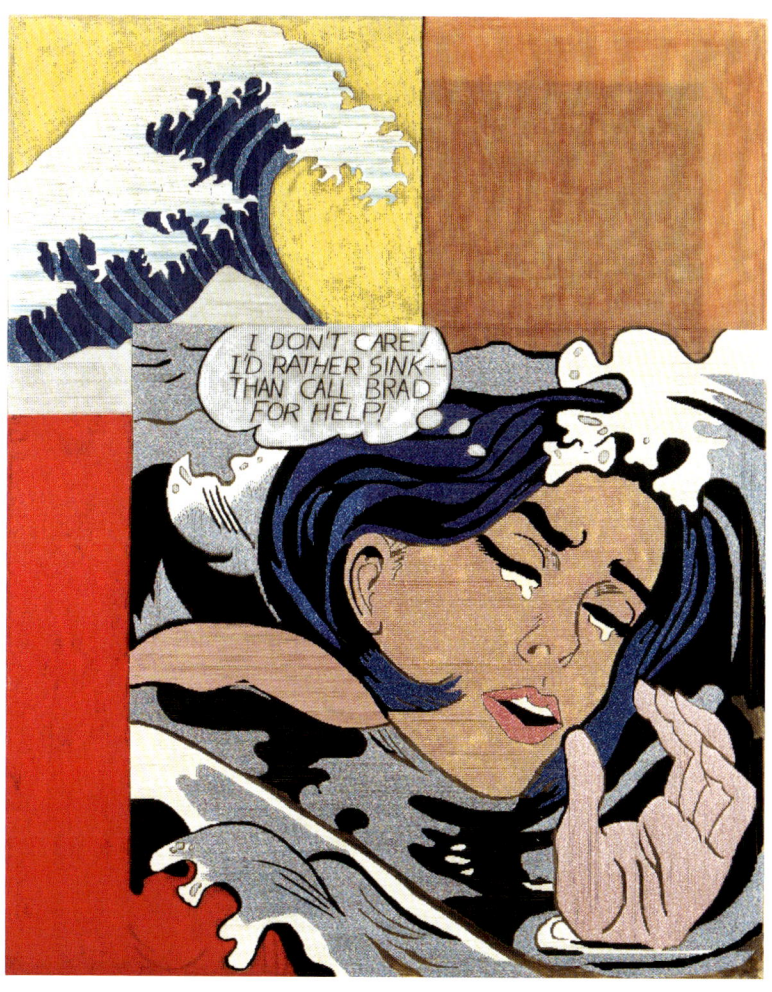

Title unknown, 1984. Thread and paint on needlepoint canvas, 39¼ x 31⅞ inches.
Collection of Nabil A. Moufarrej

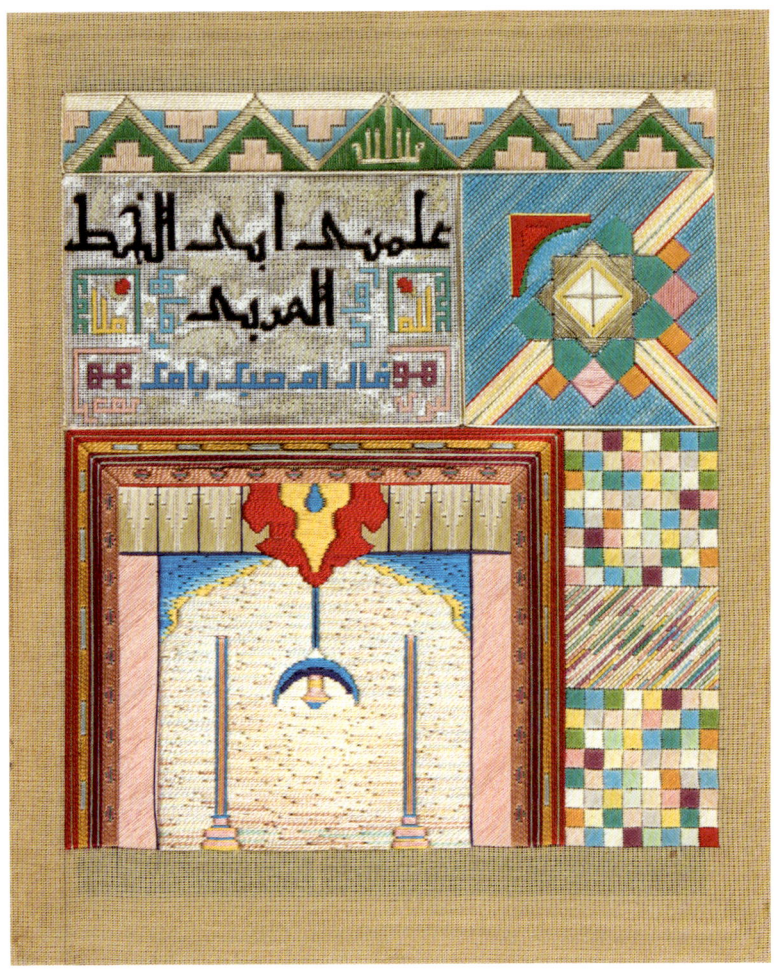

Languages, 1980. Thread and paint on needlepoint canvas, 18 ⅛ x 14 ⅞ inches. Collection of Nabil A. Moufarrej

Dean: It struck me as a critically engaged scene, by artists for artists. Full of serious fun. Now there's so much pressure toward marketability, toward the kind of professionalization that stymies aesthetic and critical discourses.

Elaine: It was politics put forward by groups like ACT UP and others. But Nicky and I also understood and had engaged with different political groups in the seventies. For me, it was AIR Gallery—the first feminist cooperative gallery, which became a model for many alternative spaces afterward. It changed my politics. It was a self-selected group. All women, all artists of different demographics and sexualities. Yet the group managed to buy a space together and managed to function—it was a true education. I am not by nature a group person, but I joined AIR for the politics. I felt that the context for the work was extremely important. I wanted to be very explicit about where my work was shown.

Dean: Did you have many conversations with Nicolas about feminism and politics?

Elaine: Politics were almost a priori understood. I don't think we had conversations specifically about it. Our conversations were more about pastiche, about free-associative logic, about translation, about the books we liked, about what it means to show in different contexts, what context meant in terms of work. And it was more about making art: "Are you having trouble with that thread?"

Dean: So the two of you recognized a shared politics—even if it was unspoken.

Elaine: It was the basis of our friendship. There just was never any question that we shared the same political ideas.

Dean: Nicolas seemed bonded to community in other ways too—in the way he wrote about art but also, I think, in the way he created

work with a group of older women who helped him with the embroidery. It made for a more sophisticated practice.

Elaine: Absolutely.

Dean: Do you think that in working with this group of women Nicolas embraced the social experience of making work—the exchanges it generated—or was it, more simply, a sewing circle?

Elaine: I wasn't there, so I can't say exactly. I think Nicky was comfortable with anyone and everyone, but what you're speaking about implies some other kind of community exchange, and I just don't know about that.

Dean: Yes, but do you know whether he was sending individual works to individual people, or if they were meeting together?

Elaine: I think they worked in his studio. There were a lot of people around him in the studio—especially when he had the studio at PS1.

Dean: How did you come to needlework? It probably ran counter to a lot of other work that was happening at the time, didn't it?

Elaine: I would like to claim that my earliest use of thread, which was in the 1970s, was part of a feminist discourse—but I really didn't arrive at it that way. It was really more to do with the thread as a line that pierced the support, that appears to be lying on top of a support but that pierces it and comes around the other side. It was truly for me an alternative way of making a mark.

Dean: So your structural support was canvas—not embroidery cloth.

Elaine: Exactly. I had no education in craft. I taught myself. I'd come from a formal point of view. I'd come through an education steeped in art history. I was reading Clement Greenberg, but with a jaundiced eye. I began to ask where all the women were. They were in

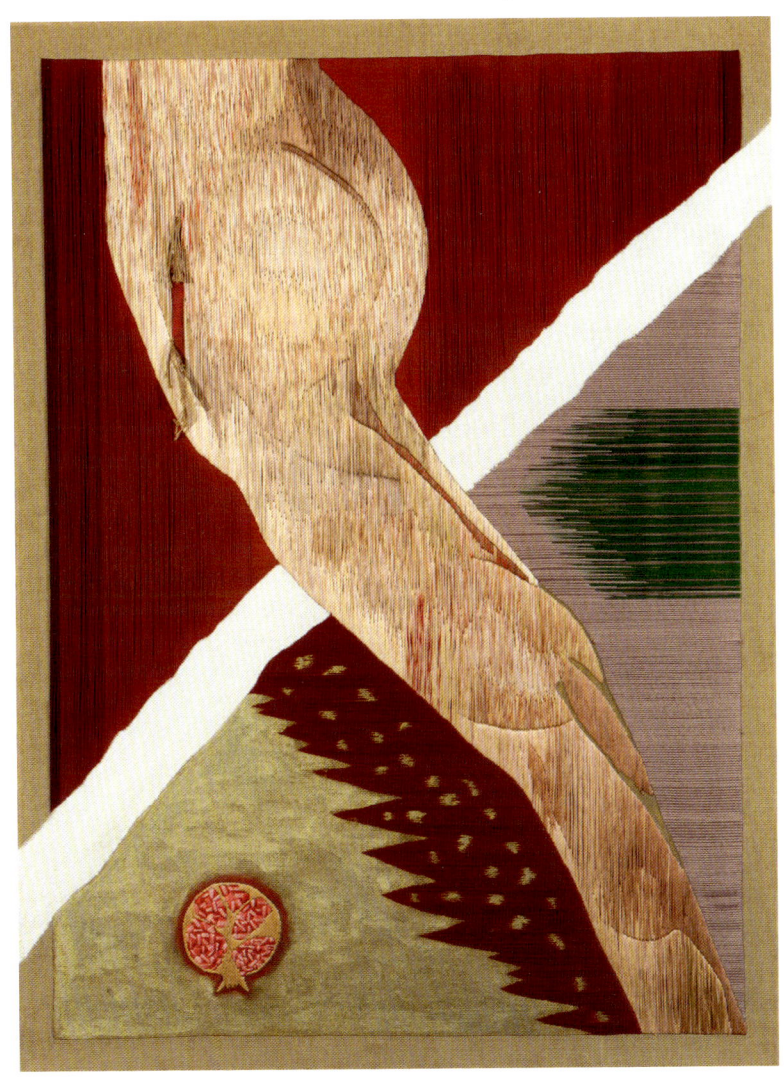

Title unknown, nd. Thread and paint on fabric, 61 x 48 inches.
Collection of Nabil A. Moufarrej

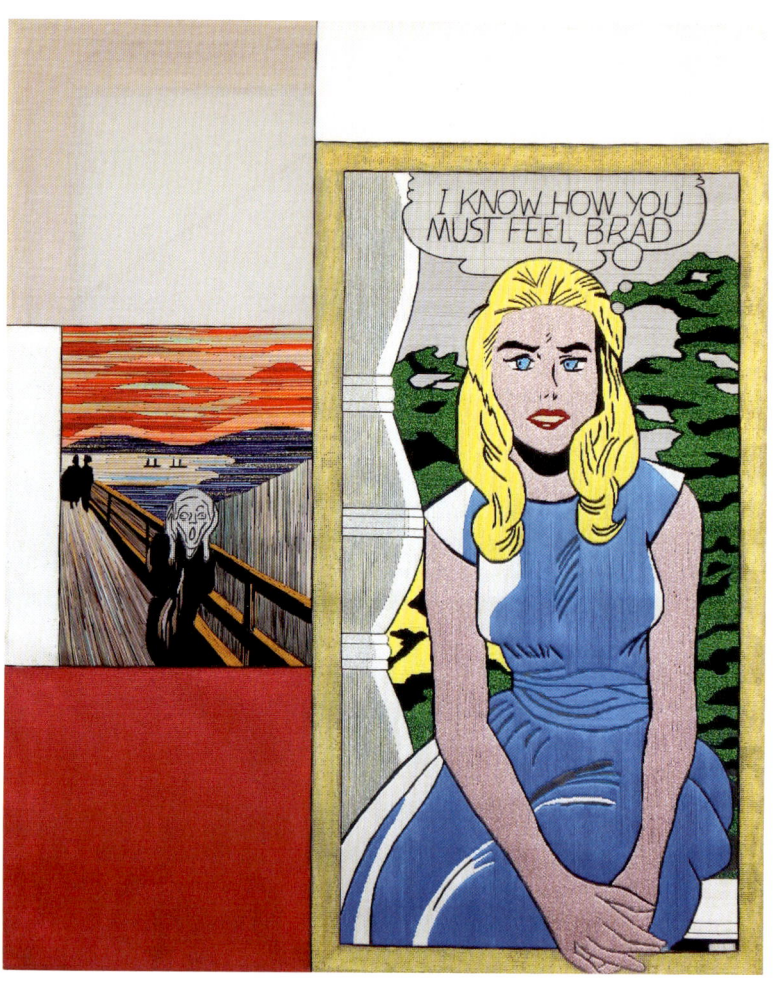

Edward Brad Munch, 1984. Thread and paint on needlepoint canvas, 40 x 32 inches.
Collection of Bradley and Holly Cole

my undergraduate school, but why weren't any of them with me in graduate school? So after grad school, I began to experiment with embroidery, and then I thought, "Oh, there's this other history," and began to investigate that. I took Josef Albers's color course, I found out about Anni Albers, and I started to read about the Bauhaus. I started to educate myself on the history of decor and the history of textiles. I really didn't find out about Womanhouse and all of that until later.

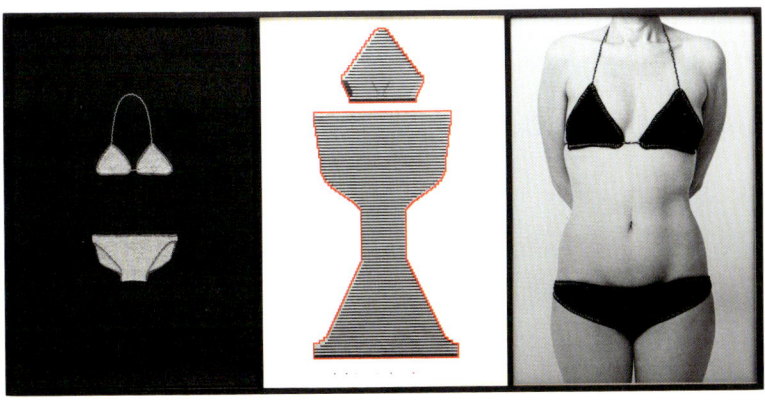

Elaine Reichek, *Bikini*, 1982. Knitted metallic yarn, colored pencil on graph paper, and silver-toned gelatin print, 41 x 84 inches

Dean: It was a time when people began to recognize and feel all of the social, cultural, and political differences. There was a fatigue with a patriarchal, hierarchical system—"This begets this, begets this"— where subjects are expected to figure out where they fall in line.

Elaine: The margin was where everything was interesting. Everybody began to look at what got left out.

Dean: Do you remember how you and Nicolas discovered that you were working in similar mediums and with similar concerns regarding craft?

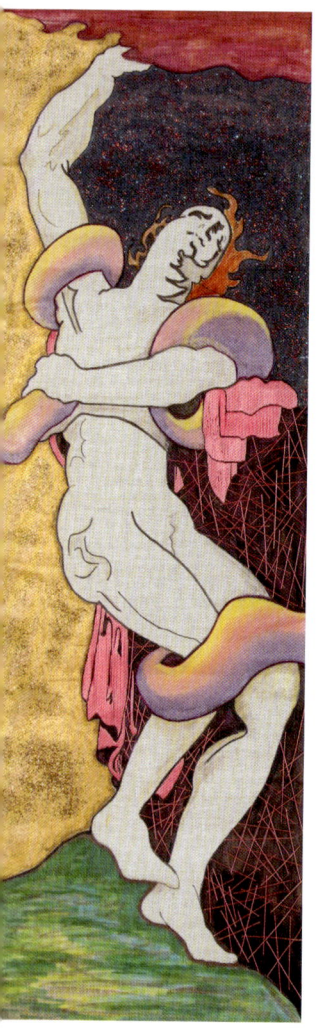

Elaine: Nicky asked me what I did, and I think I said, "Oh, I just knit," and he said, "Oh, I just sew," and we started to laugh! We then, of course, exchanged visits and started to hang out, and we talked about materials, shopping, information. Since I was slightly on the perimeter and not so involved in the social politics, he could confess his ambition without being self-conscious. Nicolas was so smart and so fluid socially, and he was as ambitious as anyone else.

My work is labor-intensive, and I do all my own hand sewing—Nicky hand-made most of his own work as well, but his process was often more communal. I'm attracted to people who are part of a community, I think, because I lack that in myself. Nicolas had a much different sensibility from my own. All that input, I suspect, just led to art for him. But he was also tired, because he dealt with so many things: the groups, the criticism, the exposure. That's very brave. People wanted to know him. Nicky was a mover and a shaker.

Dean: Yeah. I wonder if that doesn't come from Nicolas's intimate experience with exile and having to reestablish himself?

Elaine: Absolutely. He was an outsider, and when he came to New York for the first time, he finally had a community that he could relate to—and sex! It was just a cultural explosion of acceptable and celebratory sex.

Left and right: Title unknown, nd. Yarn and paint on needlepoint canvas, two panels: 18 x 54 inches each. Collection of Nabil A. Moufarrej

Dean: I remember that in the early nineties you could still go over to Christopher Street and get a blow job in broad daylight.

Elaine: There were the piers, and there was a club for every taste. A whole part of the art world went to the baths. Who you saw in their underwear was a subject of conversation. But Nicky was also very sensitive. His feelings would get hurt, and he wanted someone to talk to. When you're wearing many hats—critic, artist, writer—and you're out and about like him, you're exposed. As time went on, this was disillusioning for him.

Dean: Sure. And do you think that that's maybe why the two of you were able to become so close, because you didn't feel competitive with each other?

Elaine: We were certainly not competitive.

Dean: Yes, as I see it you shared a sensibility, a language, and had distinct things to say, which allowed a conversation to open up.

Elaine: He and I talked about the bond between art and literature because we read the same books and loved so many of the same things. We read Anaïs Nin together, and the *Alexandria Quartet* by Lawrence Durrell. It was like our own little book club of two. He liked Rilke more than I did, but we were both interested in classical Greek and Roman history—myths and stories. We talked on the telephone a lot, or I would go visit him, or we'd go out together. He was a good cook!

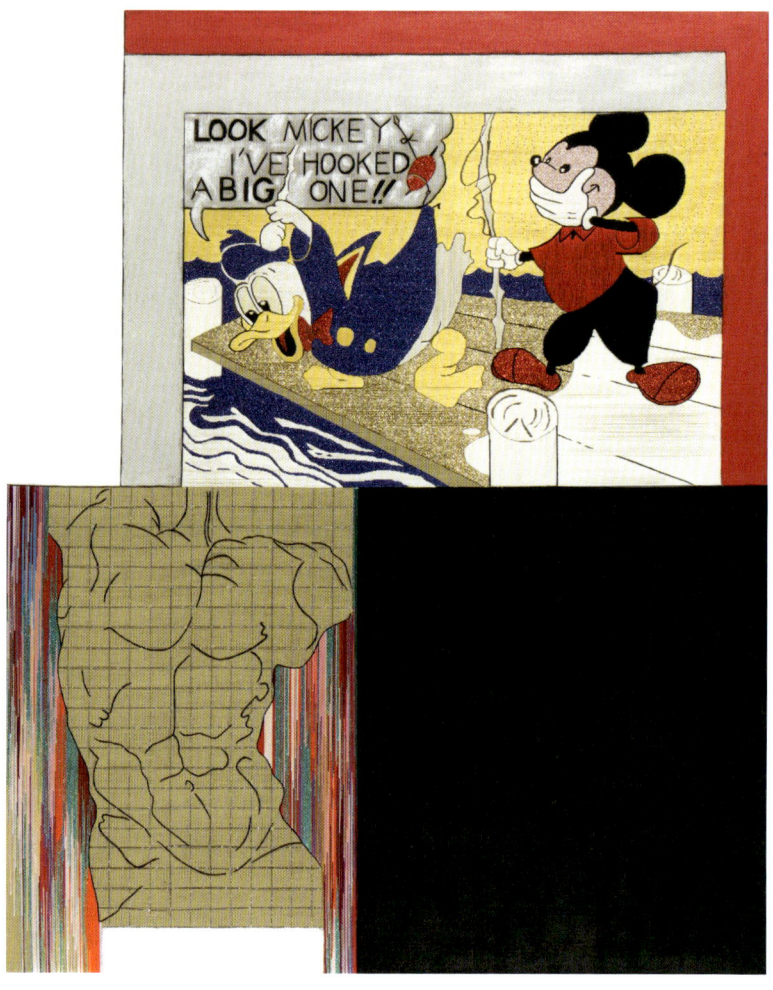

Title unknown, 1984. Thread and paint on needlepoint canvas, 57 ⅜ x 44 ⅞ inches.
Collection of Nabil A. Moufarrej

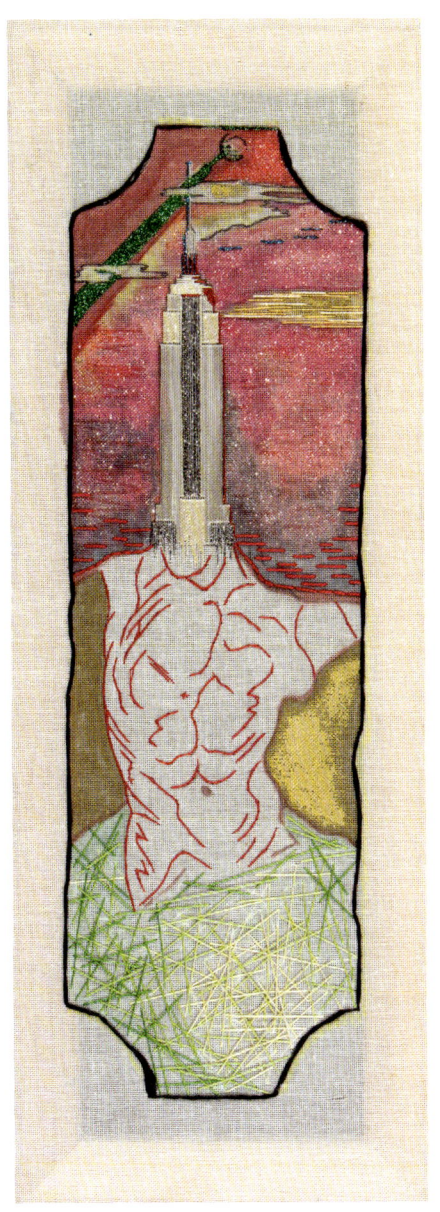

Vatican Collection in NY, 1983. Thread, paint, and mixed media on needlepoint canvas, 27 x 9⅞ inches. Collection of Nabil A. Moufarrej

I've always felt that Nicolas's life was entwined with my own. The period in my life that he was a part of completely influenced my later work. My husband died of colon cancer a year after Nicky's death—so it was just a string of *horrible*. Many of the pieces I made after that were in some way about loss and abandonment. We had talked about our work intensely for three years, but we probably knew each other for five years before he died.

When he got sick, it was very early in the epidemic. I remember he called and said something like, "I have a rash." I thought he had impetigo. He said, "Oh no, I've got spots all over the place," and I wanted to know who was doing his laundry, what kind of detergent he was using. I told him to use Ivory Snow and rinse twice. I sent him to my dermatologist, Dr. Alvin Friedman-Kien, who just happened to be one of the first dermatologists to diagnose Kaposi's sarcoma and recognize the lesions and the community that was most affected.

Dean: Thinking back, it's crushing to realize how complicated it must have been for already marginalized communities to respond to the onset of AIDS and HIV. It's not surprising to think that a disadvantaged socioeconomic status would have prevented many folks from seeing doctors when they became ill.

Elaine: No hospital would take Nicolas in Manhattan, so he was shipped over to the Bronx like some plague victim. His health deteriorated very quickly. He just got weaker and weaker. It was so early in the crisis. His friends and family went to visit him. I would go to see him with Christine Lombard, a wonderful filmmaker. The first time we went, there was a skull and crossbones on his door.

Dean: The hospital put it there?

Elaine: Yes! "Do not enter." And they gave us masks. There was such hysteria, even though by 1985 people knew AIDS was not an airborne disease.

Dean: It's apparent now that it was communities of activists who really made the difference in supplying information to the public about HIV.

Elaine: When we walked in, we whipped the masks off. I remember that the room was not as clean as it should have been. We had to fight for everything. We had to fight for someone to sweep his room. We picked trash up off the floor.

Dean: Do you remember how long he was in the hospital?

Elaine: It wasn't long. You know, if you had friends who were ill you just tried to take care of them in some way. His obituary says he died of pneumonia.

Dean: I understand that his sister Nouna was very close with him and visited him.

Elaine: She did!

Dean: She's told me about going to New York and dancing at the Pyramid Club and places like that—dressing up and going out and having what sounds like fantastic times.

Elaine: Nicky loved his sister. They were very close. He used to dress her and take her shopping. She must have been heartbroken.

Dean: His family said Nicolas was interred at a local cemetery. His final resting place, Peter Pan Garden, was chosen because, through his memory and his works, Nicolas will be forever young and will never grow old. Because Nicolas died so early in the epidemic, was it hard to find a funeral parlor for Nicolas's services after he passed?

Elaine: My husband, George, who was an estates and trust lawyer, found the place. There was no money, but we located an Italian funeral parlor.

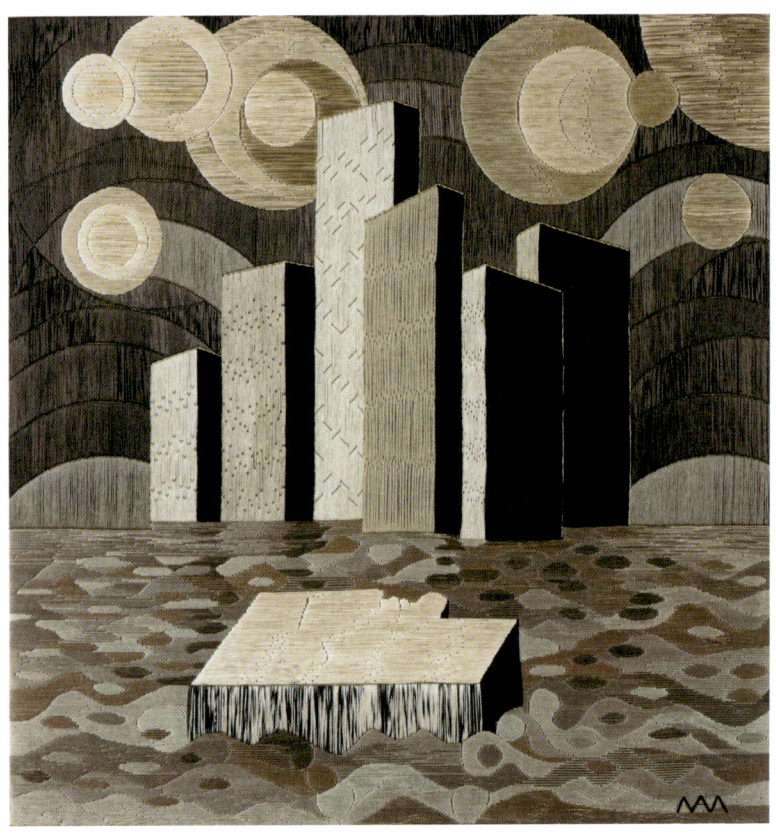

Title unknown, 1975. Thread on needlepoint canvas, 32 ⅝ x 31 ⅝ inches.
Collection of Nabil A. Moufarrej

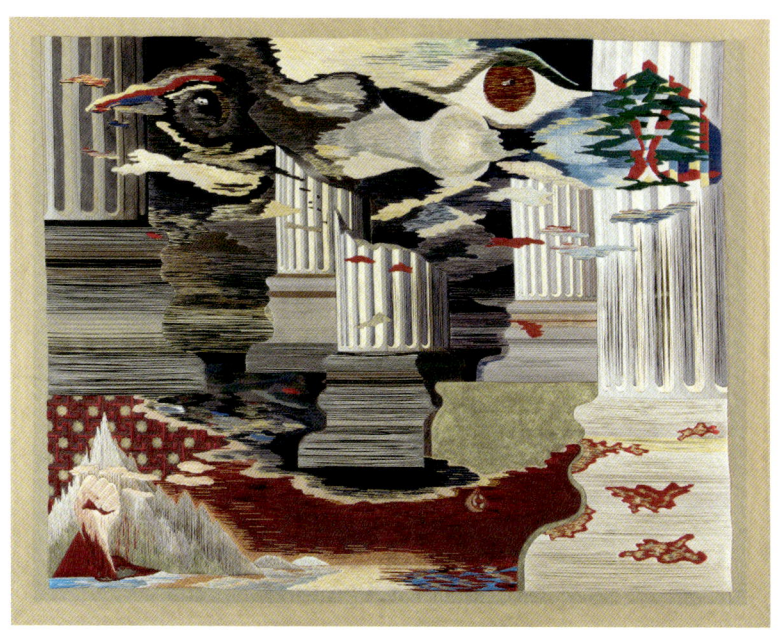

Title unknown, nd. Thread and paint on needlepoint canvas, 49 ⅞ x 64 inches.
Collection of Nabil A. Moufarrej

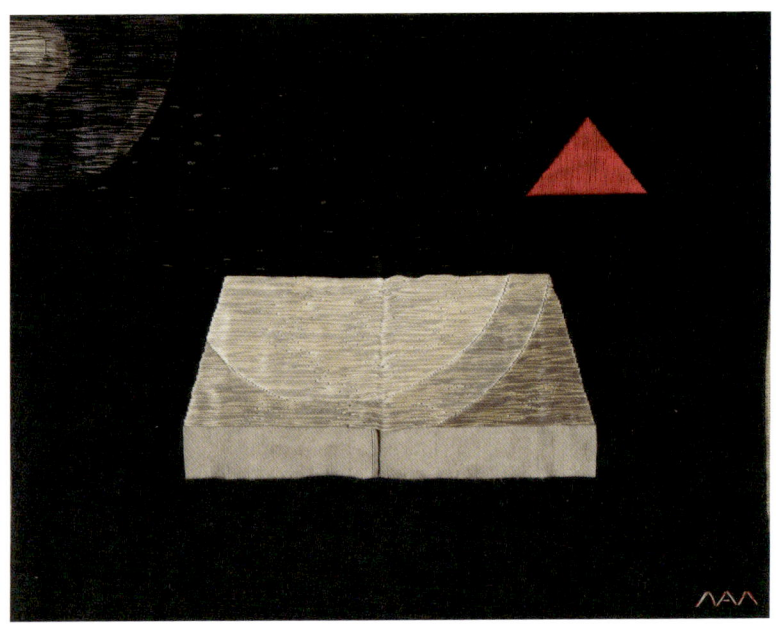

Title unknown, nd. Thread on needlepoint canvas, 22 x 28 inches.
Collection of Nabil A. Moufarrej

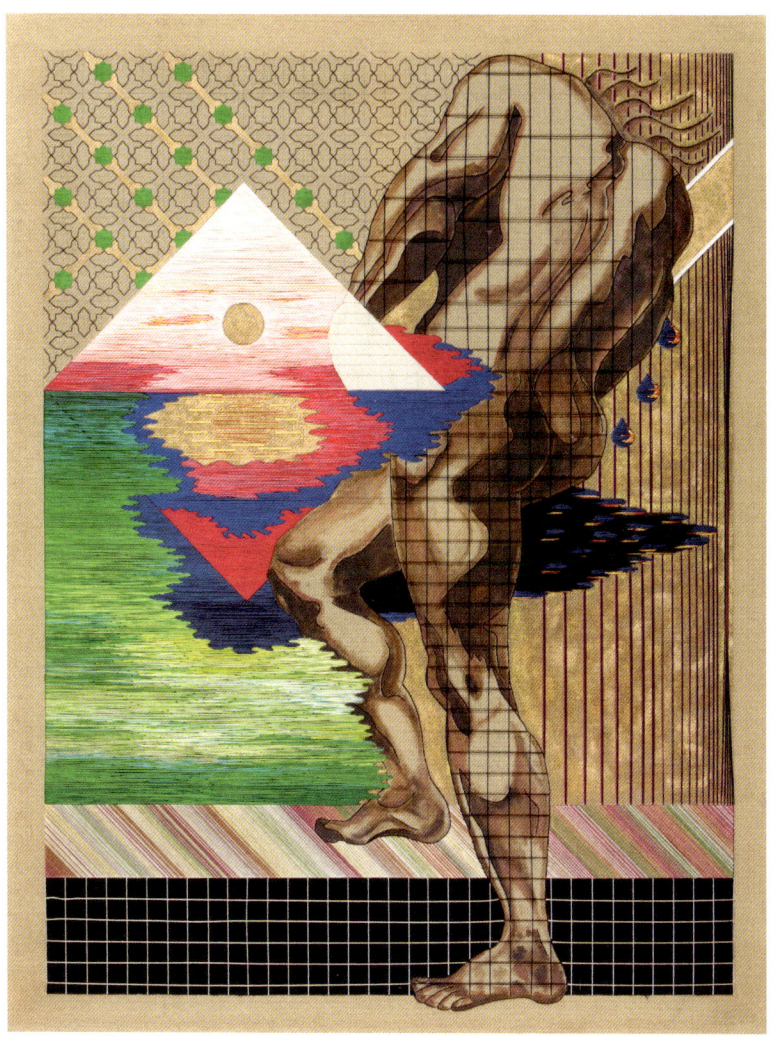

Title unknown, nd. Thread and paint on needlepoint canvas, 57 ½ x 44 ⅞ inches.
Collection of Nabil A. Moufarrej

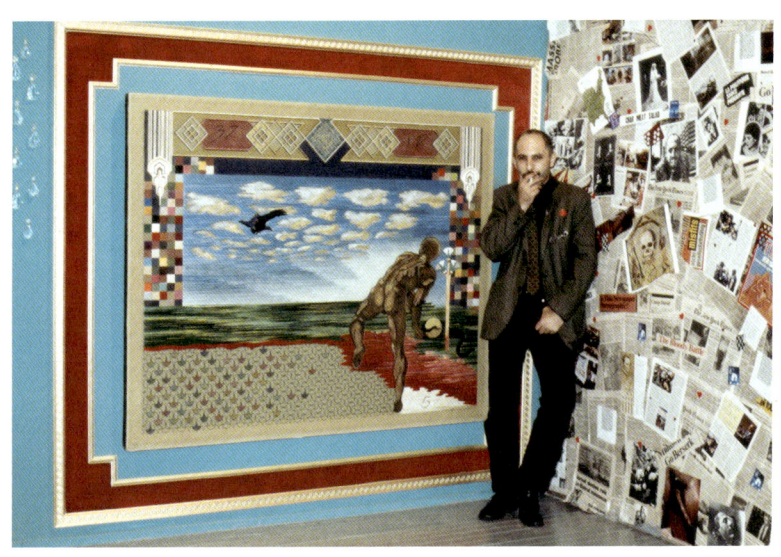

Nicolas Moufarrege's studio at PS1, Long Island City, NY, October 1982

Dean: I also understand that Nicolas had a show at FUN Gallery that opened on his birthday while he was in the hospital.

Elaine: Yes, but he never made it to the opening. We went for him. He passed away on a Tuesday in June 1985. In 1987, Bill Stelling, Tim Greathouse, Cynthia Kuebel, and I organized a show of Nicolas's work at the Clocktower. It was emotional at Nicolas's brother's house when Bill and I unwrapped everything in preparation for it. We were all still in mourning. We insisted on making a catalogue. I felt that if we didn't have a publication, the work would just slip away. It had all gone to Shreveport, Louisiana—to his family—and we despaired of ever seeing it again.

Dean: Thankfully, his family has taken great care of the work, treasuring it, and much of it is still in great condition.

Elaine: When we did the installation at the Clocktower, we painted the walls the color of his PS1 studio—turquoise—and tried to affect Nicolas's own hanging. We wanted to make an installation that was a tribute to Nicolas in every way we could.

Dean: It seems the aesthetic he developed was genuinely personal.

Elaine: Absolutely, though there were many shows that eschewed the white cube by that time.

Dean: Do you think the politics of the time influenced the way Nicolas strayed from convention?

Elaine: That's right. How did you meet Nicolas's family?

Dean: After first discovering Nicolas's work, I read in a *New York Times* obituary that he was survived by a brother and sister in Louisiana. So I called 411 and got a listing in Shreveport and dialed it up. I had no idea how the story would go. I talked with a gentleman on the other end of the line—Nicolas's brother, Nabil. We spoke for a bit, and he

Title unknown, nd. Thread and paint on needlepoint canvas, 25 x 31 inches.
Collection of Nabil A. Moufarrej

Title unknown, nd. Thread on needlepoint canvas, 26 x 20 ⅛ inches.
Collection of Nabil A. Moufarrej

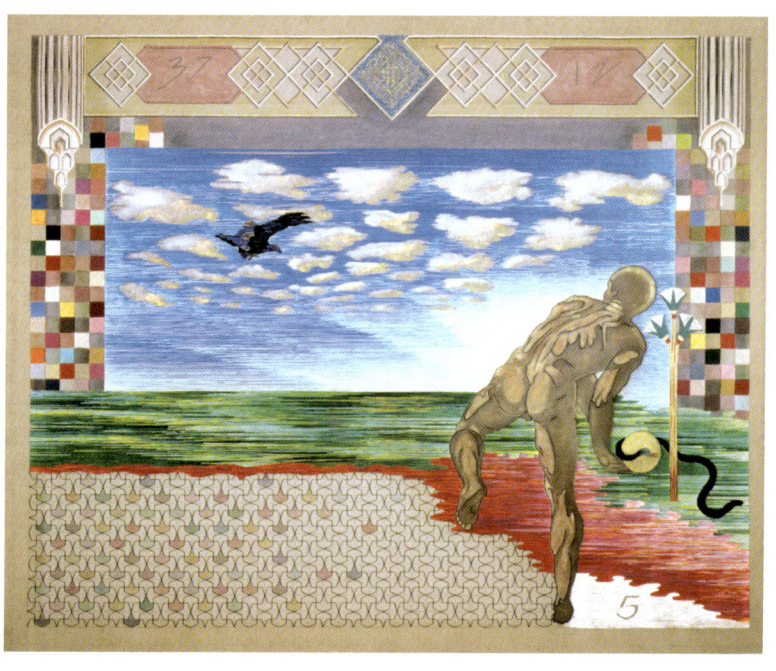

The Fifth Day, 1980. Thread and paint on needlepoint canvas, 51 x 64 inches. Collection of George Waterman III

asked for my contact information. A short time later, I got an e-mail from him full of attachments—photographs of Nicolas's work lovingly installed all over his and other relatives' homes. They've given his work a place of pride.

Elaine: That's wonderful to hear.

Dean: In 2008, I curated the exhibition "Side X Side" for Visual AIDS at La MaMa Galleria. It included work by Nicolas as well as Scott Burton, Kate Huh, Martin Wong, and Carrie Yamaoka. George Waterman loaned Nicolas's painting *The Fifth Day*—it's a fantastic and important work. I remember taking a drive up to pick it up and then wrapping it in plastic and putting it in the back of a pickup truck. It fit in perfectly—it's a pickup-truck-size painting.

Elaine: Well, if you moved as much as Nicolas did, you wouldn't make loft-size work.

Dean: I had a couple of goals with that exhibition. I wanted to bring women I knew as caregivers to the table—it seemed so many of them had been edged out of the conversation. These were people who were dedicated activists. I was also acutely aware that the men in the show were no longer with us. I wanted the exhibition to reflect this, so I included works made over the arcs of the artists' careers—some of them cut too short. The structure helped to communicate this sense of loss, of absence, and left viewers wanting more. It was palpable, for me at least. It was a time in my curatorial practice when I was interested in asking where the omissions were, where the discrepancies were. Who had been marginalized? Who was no longer in the room or not invited to the table?

Elaine: Alongside his writing and artwork, Nicky put together these really exciting shows with his particular sensibility. They were salon hangings, floor to ceiling, and had a kind of swarmy

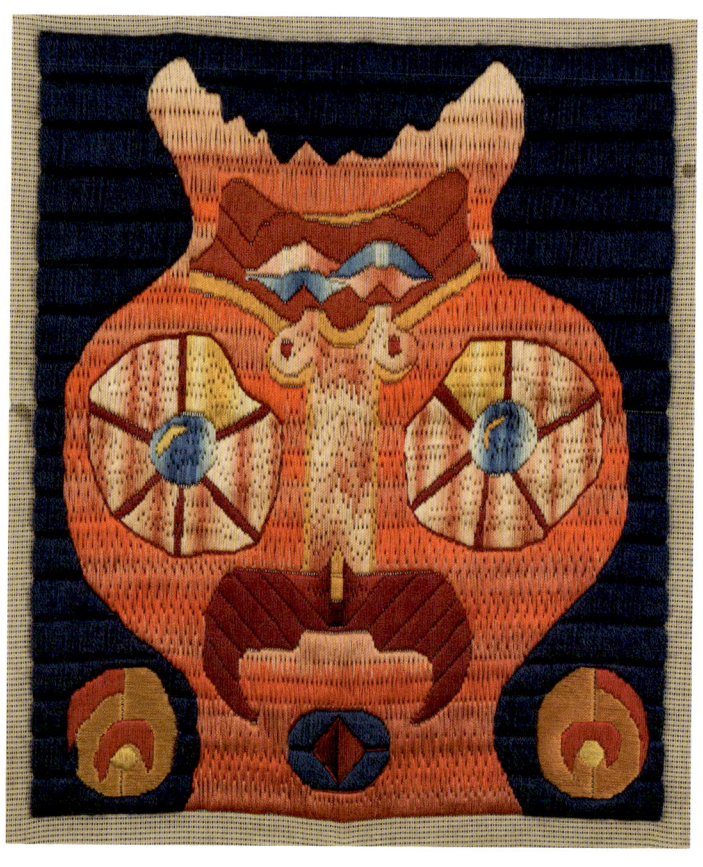

Title unknown, nd. Thread on needlepoint canvas, 17 x 14 ½ inches.
Collection of Nabil A. Moufarrej

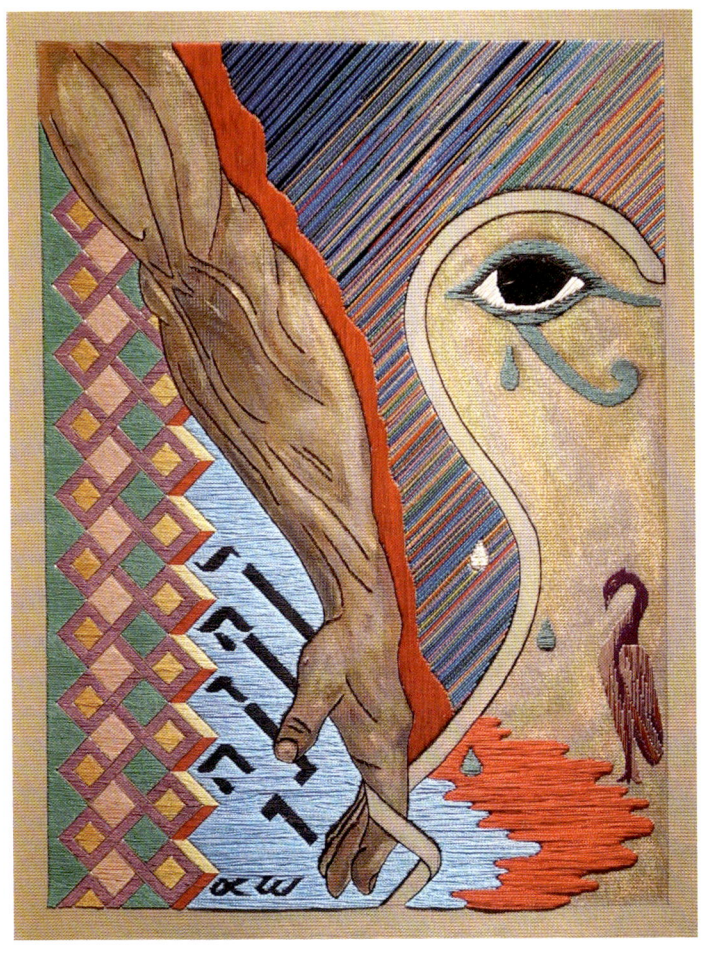

Untitled, 1983. Thread and paint on needlepoint canvas, 26 x 19 inches.
Collection of Michèle C. Cone

heat to them, a real perfume. I specifically remember three group shows: "Intoxication," "Ecstasy," and a little Christmas celebration in his studio for which he asked his friends to make stars, because we were all "stars."

Dean: He was inclusive. He wrote about "Intoxication" for *Arts Magazine*.

Elaine: His writing was high-pitched. Adjectival and witty, tsunami-like. He wrote in exuberant prose that matched his own flamboyance.

Dean: Flowery?

Elaine: Florid!

Dean: And did he go in for superlatives?

Elaine: Yes and no. It has a lot of energy to it. It's a particular prose. He was able to share his enthusiasm for what was going on. He was an enthusiastic supporter of what he believed in. At the end, he was disillusioned because I think he also hoped for a degree of reciprocity.

Dean: When culture begins to be capitalized and monetized, it too often moves away from those conversations that are community- and content-based.

Elaine: East Village galleries had to make ends meet. You know, Gracie Mansion started a gallery in her bathroom, but once she got a real space there was real rent to pay.

Dean: Nicolas's writing, his curating, and particularly his artwork were very continental, very urbane.

Elaine: And it's joyful, it's witty! It's not angry, punitive, or didactic—it has great joy in it. The work is generous. It's full of cross-referencing. He just sampled it all—high culture, low culture—threw it all in the blender.

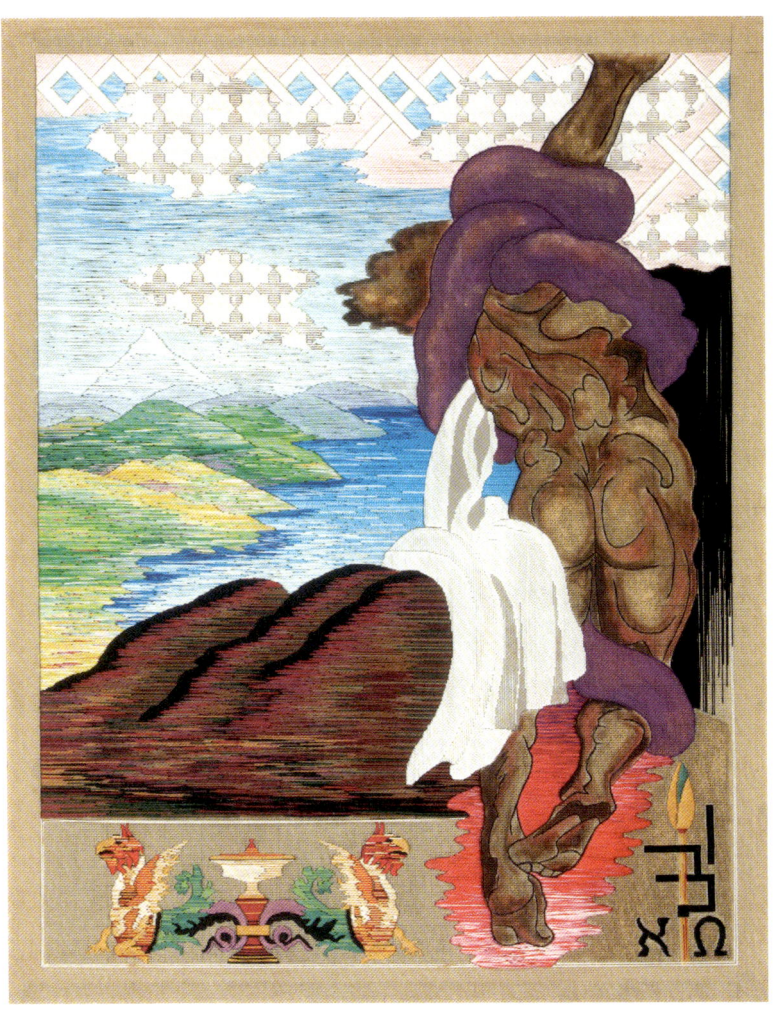

Title unknown, nd. Thread and paint on needlepoint canvas, 39 ½ x 32 inches.
Collection of Nabil A. Moufarrej

Dean: It's also not an acerbic, biting wit or an ironic wit. There is a generosity in the work. It's antihierarchical. I think that there's a certain degree of absurdity in his work because of the unlikely bedfellows that ended up in it.

Elaine: Yes! I love that. Nicolas's work is conversational.

Dean: It's true.

Selected Writings by Nicolas A. Moufarrege

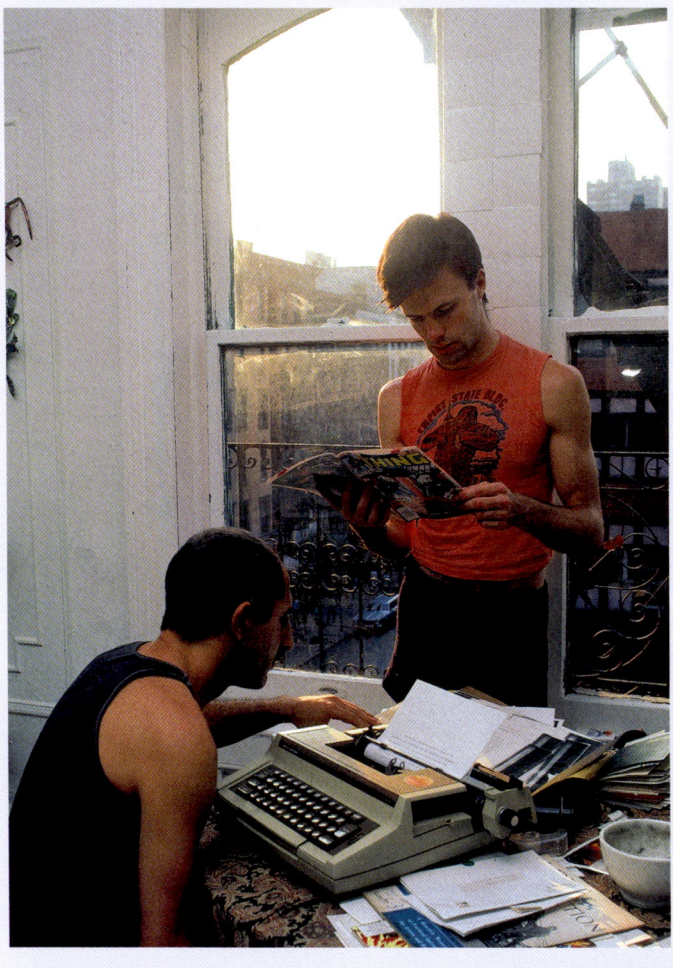

Nicolas Moufarrege, at typewriter, and Chuck Nanney, standing, 1983.
Photo by Dirk Rowntree

Another Wave, Still More Savagely Than the First: Lower East Side, 1982
Arts Magazine, **September 1982**

When I moved to New York, a year and a half ago, it took me less than a month to decide where I wanted to live. A year later I am still in a sublet on the corner of St. Mark's Place and Second Avenue. A couple of buildings down, a new gallery opened in March: Gallery 51X (51 St. Marks Pl.). . . . The FUN gallery, a room sized storefront at 229 E. 11th St. opened a little less than a year earlier. . . . Today, a year later, Patti Astor and Bill Stelling of the FUN are looking for a larger space.

Gracie Mansion, Loo Division (432 E. 9th St.) is declared a gallery in early spring; Gracie shows her artists in her apartment, on her bathroom walls. . . . Alan Belcher and Peter Nagy are two more artists who open yet another space, the Gallery Nature Morte (204 E. 10th St.). . . . David Kirkpatrick uses his space for performances and installations. He shows the works of neighbors and friends . . . at the LIFE gallery (10th St. and Avenue B). . . .

Crowds throng the openings, the art is reasonably priced, and the people are buying. The work for the most part is astonishing and sincere. Even the most hardened street guerrilla is anxious for a gallery showing; some have received acclaim in the mainstream but they are more comfortable showing with their peers and they all identify with an East Village state of mind wherever else their own personal roots may lie. . . .

Everything is moving so much faster: waves, volcanic eruptions, high-voltage currents. Boomtown, a pulsing heart within the metropolis, the East Village, Manhattan, where different drummers unite in a Zeitgeist despite their varying and very personal rhythms. The need to communicate is overwhelming; in more important ways than literally, the boundaries of art have gone beyond the stretcher and the canvas. The spirit of the age is apparent in the mélange of people that live in the neighborhood, a neighborhood that encourages one to be the person he is with greater ease than other parts of the city. The integrity of the art produced or shown there is therefore not surprising. . . .

This is 1982 and Jean-Michel Basquiat's hobo signs and Keith Haring's hieroglyphic cartoons have gained world renown. In 1979 Fred Brathwaite and Lee Quiñones met in a New York open air subway train depot. How does one pin a year on Futura 2000? In 1981 Joanne Mayhew-Young, now known as Gracie Mansion, sold artwork out of a limousine parked on

the corner of Spring and West Broadway. The Mudd Club, Club 57, and PS1: Kenny Scharf's neonaissance radiated its tinsel. Eric Mitchell's film *Underground U.S.A.* starred Patti Astor and Rene Ricard. Patti wore a dayglo mini to Club 57 and a dozen artists tagged it. Rene Ricard spun on the dance floors; writing of tagging, rapping, and breaking he became Rene Ricard. Who was it that almost got arrested at La Guardia as he attempted to spraypaint a 747? History....

I believe the role of the artist in these green '80s is similar to that of the rock musician of the '60s. A different pop art, politically and socially relevant, a reaction to the reckoning severity of the '70s, lives in the art itself and in the public's interest in it. It is the crowd that is the artist's audience and not merely the gallery-frequenting public.... In order to reach more people, art is hitching onto entertainment: serious and/or fun, a new and different audience is being touched. A different significance appears; the visual artist expands his realm into music and poetry and performance. To move the crowd the artist impersonates himself, translates himself into what is obvious and presents the whole person and cause in a simplified version. The artist and the persona are but the same person and the repetitive drumming rhythm of the sign and the image is required to enable him to reach the crowd. This is much like advertising and the images are more significant and meaningful than most of what Madison Avenue offers....

Lavender: On Homosexuality and Art
Arts Magazine, October 1982

No, I am not really interested in what an artist does in bed and to whom, but, in all honesty, if you want to tell me about it, I'll listen with more than a grain of attentiveness. Nor do I believe that it is the sexual act that is the sole creative urge, and if someone were to ask if a certain painting were gay or not, I would be bound to retort that paintings do not sleep with other paintings regardless of their gender. Moreover, I do not perceive homosexual sex as an extension of heterosexual sex; my perception of an extended sensibility does not restrict itself to gay or lesbian artists—it is a liberatory seal, a state of mind, maybe occasional, more often constant. It is important to draw on one's total self to become the person one is and to divest oneself of any sense of shame in reaching that goal. Extended

sensibilities comprehend links to one's roots, to childhood and things past, the rejection of all forms of oppression, an inebriated compulsiveness and an equally inebriated search for beauty, the abrogation of masculine and feminine stereotype models, a certain sense of style that may incorporate a quirky aesthetic, a surrogate self, but ultimately and always a strong sense of personal affirmation....

All that glitters is not gay, and not all gays like glitter; many do and many others who are not gay also like glitter. Different homosexuals have different personal, cultural, and aesthetic identities. We are faced with artists who happen to be homosexual rather than a particular homosexual aesthetic, and if that *had* to be defined it would clearly, and could only, be a manifold, mobile, and mercurial aesthetic....

X Equals Zero, as in Tic-Tac-Toe
Arts Magazine, **February 1983**

What is the pregnancy of words and pauses? I also want the letters to dance, to twist and coil, to swim like sperm into a molecular code spelling a baroque and different double helix. Impregnating and impregnated, different sensibilities, black and white numbers, letters, ink and paper, Arabic, Roman, italic; what's the difference when all tongues have the same color? The hard on of space against the womb of time.

New York, the '80s, stretching across and upwards. Au coeur du monde, jouant aves des ballons et une petite trompette d'enfant: Je travaille à la *fin du monde*. We grow like trees amidst skyscrapers, not in one place but everywhere, hyper-hybridized not in one direction but equally upward and downward and inward and outward. Our energy is at work simultaneously in the trunk, branches, and roots; we are no longer free to do only one particular thing, to be one particular thing....

Every mature art has a host of conventions as its basis insofar as it is a language. Convention or grammar is the condition of great art. It is such a grammar, the grammar of the myth, retabulated to include the ciphers of our collective unconscious through the intelligent use of not one but all mythologies and symbologies, past and present, liberated, that will allow man to achieve a dynamic realization of the center of his being and presence. The myth, woven with the understanding of the elementary ideas, within the ethnic, recreated in its completeness with the conciliation of

opposites, is the substance and catalyst of the necessary reaction that will awaken love and accomplish a creative rebirth.

East Village
Flash Art, March 1983

In Lower Manhattan life goes on non-stop: The sun sets, the sun rises; the newspaper stands are open twenty-four hours, magazines from all over the world. Art, art, art and lots of pictures of art. New wave is *passé, blasé* is out and formal severity's high-tech salons are of a distant yesteryear. The eighties are more than a danceable tune; there are also the words to the song and the visual impact of the dancing crowd....

It is winter. The galleries in the East Village aren't heated. The gas heater at FUN gallery is jokingly referred to as the best sculpture in the joint. The galleries aren't heated but the crowds are coming—because the art is hot. With good reason. The vehement return to an imagistic and figurative mode allows the art to reach and touch a broader and rapidly growing public. A distinct immediacy is apparent in many current works. The levels of interpretation are manifold and varied but the initial visual reaction often strikes the viewer as a flash. Everything that pleases has a reason for pleasing.... High and low art intermingle, causing a headiness in the streets and in the arteries and veins. From retina to grey cell the art emerges: personal, funny, provocative, reckless and ambitious. Socially and politically relevant, it proposes solutions and rejects fear, rife with vitalism. It gushes forth widly with a kind of no-holds-barred intoxication.

The artists of the East Village/Lower East Side are equally gallery owners, painters, sculptors and photographers. They are movie stars and poets, musicians, performers, editors and executives. They do not necessarily live within the geographical boundaries of this cultural area, but recently the limousines have been arriving *en masse* to grab a piece of the action.... But the East Village is also a state of mind, a choice which allows one to be oneself amid a spectacular *mélange* of people, an open, unwalled ghetto of talent and understanding....

Patti Astor puts up a scarlet-tipped hand to hold back the rush. Each opening, the FUN gallery is torn apart, new walls are built, others destroyed. The FUN is the most beautiful gallery space in New York. Wide, full vitrines open on the street, the volume of the space inside is perfect; and in the

back, a yard. Indoor/outdoor is just one of the dualities in the very private/very public polarity of the FUN....

Basquiat has revised the grammars and recreated his own. Distant and aloof, a legend and a superstar at twenty-one, Warhol has added him to the ranks of Liz and Marilyn in a portrait, atop one of Andy's "piss paintings." Piss elegance never looked so good.

Arch Connelly's work subverts the essentials of elegance: pearls and black. He studs tables with pearls creating an object that is beyond furniture, sculptures that become jokes on fashion and a Byzantine visual experience. Clusters of pearls amass in paintings that sparkle, reflecting light like Van Gogh's stars. Paint occasionally intervenes, winding its way through pearly areas, organic veins lush with color, hybridizing the work. Connelly's art is mannered, effete and snobbish, but always formal, witty and stunning....

Art is the chief mode of stating self. It has shaken off the fetters of medium and become social. To be an artist is not to be a member of a secret society; it is not an activity inscrutably forbidden to the majority of mankind. Art is saying what and who you are in the way of your choice....

Out on the streets I run into David Wojnarowicz. There are many East Village artists without East Village gallery affiliations; some with no gallery affiliation whatsoever. However, Wojnarowicz's work is heart and soul of the neighborhood.... Wojnarowicz's paintings interweave myth fragments from these streets with others of more exotic and foreign origin. His *Junk Diptych* reveals the seamier side of the East Village; drug overdose and tragic death. I never said art had to be cheery. I never said the East Village was all bubbly bits of gaiety and champagne. But we do have a good time.

Intoxication: April 9, 1983
Arts Magazine, April 1983

Intoxication is extreme romanticism, often of the involuntary, occasionally of the intemperate, and ever of the inviolable....

I have drunk my fill. Over a hundred artists in a show that opens on the date of Charles Baudelaire's birth. We had originally planned to open on April Fool's Day, the first; it turned out to be Good Friday. It was appropriate to postpone. I always see relationships: a fatal destiny, an unpremeditated appropriation, an intoxicated appropriateness.

One must always be intoxicated. That's where it's at: it's the only issue. So as not to feel the horrible burden of Time that breaks your shoulders and bends you to the earth, you should get intoxicated ceaselessly.

But with what? With wine, with poetry or with virtue, as you will. But get intoxicated....

What is intoxication? It is an end, I advocate, rather than specific means. It is a definition of being, an expression of memory and desire; broken images are made whole. Intoxication is a heady frenzy culminating in an intersupersonical glow. Inter, super, sonic, person. And what is intersupersonicality if not intoxication? The multi-dimensional primal levitation; the abstract existence in chronical rotation; a factual presence framed in cosmic absence; the refractive animus of personal experience moving around an exact sidereal syncretism. So complicated and yet so simple, all encompassing with unbound joy.

Intoxication is extreme romanticism. We are the most romantic species on this planet. We have striven for the universe, adored what we did not understand, and decided that the person who invented the wheel was more important than the person who invented chocolate pudding. Why? It could have been otherwise.

The word *art*, and therefore *artist*, the human subject functioning in the life circuit, is magical. The state of being an artist is a life of magic: spirits and spells, exorcisms and fetishisms. The artist is a medium, a shaman, a manipulator of images and signs. Was it the children or the adults who wrote, drew, and painted on the walls of prehistoric caves? I am not sure how we could ever tell for sure the ages of these originals. I know we have been able to trace the dates of the imagery in time though the pieces weren't necessarily signed and dated. The language of the image, the experience spelled out: figurative writing and the writing of the figure; form and word, figure, letter, numeral; story, dot, dot, dash, dot, message; speech and figures of speech.

Communication. Intoxication with communication, with creation, with the self, alive and there though surrounded by millions and millions of other humans, like and unlike him/her. All men are created equal—not all men are equal. There are those who seek and discover the artist in themselves, those who stumble on it by accident, and those who only see it flickering and never hold on strong enough to will their experience of it stronger and more enveloping. But it is always us, you and me....

Intoxication is within the artists, though one may look for it outside oneself. It is precisely situated neither in choice of subjects, in the medium and in the manner of its application, nor in exact truth. It is a mode of feeling....

I am one thing, my writings are another matter. Every attainment, every step forward in knowledge, follows from courage, from hardness against oneself. We strive for the forbidden: intoxication.

Statistics: I am my being. True, sometimes being and having are different, but in the study of Language we learn these conjugations together, first, before any of the other verbs. No miracles and no red herrings. No beginning, no equipoise, and no end. Birth: I am had—I have been. I feel a vacillating timelessness where past, present, and future concoct a unique potion. Intoxicated, in a tenseless tempo of unstrained and unstrung yo-yo freedom....

Everything happens involuntarily in the highest degree but as in a gale of a feeling of freedom of absoluteness, of power, of divinity. The involuntariness of image and metaphor is strangest of all; ... everything offers itself as the nearest, most obvious, simplest expression....

All the events then slipped the fetters of mind and emotion; I have drained you. I am thirsty still, but now I know the flavor of the universe. I am intoxicated on it all; I know firsthand the longer duration of elevated feelings. What has been only now and then as an exception is perhaps the usual state for future souls: a perpetual movement between high and low, a continual ascent as on stairs and at the same time a sense of resting on clouds.

These words, dovetailed with Egyptian dancers and Sumo wrestlers, flax and Flaxman; the lightning breaks haywire, beserk; a serpent coiled on a mound, the lion, the eagle; Christmas trees off of Second Avenue and Persian horses from *A King's Book of Kings*. Mishima's fan waves to Baudelaire and Poe; deciphering García Márquez and Nietzsche, poets and scientists; the wind wipes out the city of mirrors, stars die, dawn. It is the hour of intoxication; with wine, with poetry or with virtue, as you please. I'll come and I'll go with the sun and the sea.

The Mutant International; II: The Still-Life Victims of the Painter of a Thousand Perils
Arts Magazine, October 1983

We left off with mountain shepherds exploring the countryside. Mutants in the big city, we're only sixteen years away from the end of the century and a christened second millennium. How many thousands of years from the Ice Age? Evolution is beyond mere progress. The sheep are counted in the hours before we turn to sleep, after the phone has stopped ringing and the VCR is turned off. We have manipulated our chemistry and continue to do so. Neurons tingle tentacular as the chemicals assimilate into the blood: alpha, beta, gamma, you-name-it waves—original, magnetic, invisible. Ink. The needle bobs up and down the moving chart; colors, sounds, textures, tastes, smells, thoughts, ideas, and memories become shaky zigzags, sharp hills, deep valleys, ups and downs. A drum's roll flicks the wind. Strains of an accordion intermingle with the notes of a flute. The disc jockey mixes and spins with different speeds, hands on the turntable and spliced tapes. . . .

Knowledge? For me it is a world of dangers and victories in which heroic feelings, too, find places to dance and play. Life as a means to knowledge—with this principle in one's heart one can live not only boldly but even gaily, and laugh gaily. The lovely human beast always seems to lose its good spirits when it thinks well; it becomes "serious." And "where laughter and gaiety are found, thinking does not amount to anything": that is the prejudice of this serious beast. Let us then prove that this is a prejudice. . . .

The mutant, conditioned by culture, learns the pleasure, the aesthetic sensibility in fear, and with a gale of laughter, strengthens and vitalizes hope. It is time to lift the Judeo-Christian taboo: in the eyes of God, the comic does not exist; Christ never laughed, and there are no jokes in the Old Testament. It's funny! Similarly, the deification of painting does not allow for laughter; the serious and solemn is required. I, however, do not turn to a painting in prayer; rather evocativeness and stimulation are what make me decide whether a picture pleases or not. And if a picture cracks me up, it doesn't mean the abolition of Latin. It's outdated, that's all, and the mutant speaks better English. It's also exciting to imagine the museum halls of tomorrow echoing with guffaws and merriment. Let's face it, most painting is still stuck up in the fine-art etiquette of seriousness. Wit is acceptable but the comic cartoon is often enough dismissed as low and coarse. Give me a break. . . .

The Mutant International; III: The Last Star ... Aurora
Arts Magazine, **November 1983**

Sometimes I sit down and try to remember; I actually go beyond the basic situation or fact I am trying to remember. More often, memory just happens in me.

My robot form was smashed, but my living mind survives, somehow becoming one with the clay. My mind gives the clay life. The minerals become crystal; the retina welds itself onto the image. Shapes appear. I look out of my window; the men and women on the streets have shapes similar to mine. Those of my dreams have words etched on their toenails....

Desire and vertigo grow larger as they approach each other. When they finally touch and blend, then, through a leap, a start of my whole gaze, I attain myself; I attain the concrete feeling of existence, which is wholly enveloped by death. I am a New York peasant caught in the splendor of destiny. There is a fierce edge to the air that makes the eyes smart....

The writer finds himself in this more and more comical condition of having nothing to write, and of being forced by an extreme necessity to keep writing it. Having nothing to express should be taken in the simplest sense. Whatever he wants to say, it is nothing. The world, things, knowledge are only reference points across the void. The unknown masterpiece always allows one to see in the corner the tip of a charming foot (*le pied);* this foot prevents the work from being finished, but also prevents the painter from facing the emptiness of his canvas and saying, with the greatest feeling of repose: "Nothing, nothing! At last there is nothing." The study of beauty is a duel in which the artist shrieks with terror before being overcome by the fireworks of laughter.

The Mutant International; V: Now Playing Everywhere
Arts Magazine, **January 1984**

There is only one resolution, for this new year, 1984, or for any other. It is quite sentimental, but by no means apologetic for it is the only resolution: Love, that *other* four-letter word. And if I begin with Love, it is because Love is for everyone—and they will deny it in vain—the greatest thing in life! Let Love be the calmative, the child's pacifier, but also the stimulant; an exhilarating and strengthening potion, the gymnastic of pleasure, and a perpetual encouragement to action. To those for whom nature is cruel and time is precious, let Love be a burning draft which inspires the soul.

And we shall not forget that fate possesses a certain elasticity, which is human liberty.

A general rule: beware of the moon and the stars, of lakes, guitars, rope-ladders, sponges and horizons, and of all love-stories—yes even the most beautiful in the world! But love dearly, vigorously, fearlessly, orientally, ferociously. Relentlessly. It is not always easy—one side always loves more than the other—and hatred is unmistakably involved and suffering. But Love accomplished, awakened, is elation, ecstasy, joy, laughter. It *is* Survival. The only resolution. I don't care how impossible it may seem, how vaguely in the dark, dismal horizon of war it flickers; it remains the unique solution/resolution. The moonbeam folded lightly with a dream. It is from the solution that you obtain crystals. . . .

Never in my life have I worked so hard as in these last two months; in fact I have worked *for* all my life. I have laid the foundation for a magnificent work. Everyman has his special secret. Many men die without having discovered it, and they will not discover it because, when they are dead, neither they nor their secret will remain. I died and I have risen from the dead with the key to the jewelled treasure of my last spiritual casket. Now I shall open it far from all borrowed inspiration, and its mystery will spread through the most beautiful of heavens and earths. When the work is ripe, it will fall. I don't mean to be enigmatic, simply that I have found the key to myself, the crown or the center—the center of myself where, like a sacred spider, I hang on the main threads which I have already spun from my mind. With these, *and at their intersections*, I shall make the miraculous laces which I foresee and which already exist in Beauty's bosom. . . .

The Mutant International; VII: Time and Timing, Shelter and Storm
Arts Magazine, March 1984

The great artist realizes his vocation in an instant. An instant that becomes a lifetime. A lifetime spent wandering in and out of storms and shelters. Stories become History and cottages rise into skyscrapers. In the distance, a mantle-wrapped figure appears as a shadowspace on the horizon line; close up, a bewildered scout. What do we know of the essence of the atom, its nucleus? Do we live under that upside-down cupola, that which is both

moving and unmoving? It is veil upon veil; one is like a figure painted on a wall, and one can only bite the back of one's hand....

The time of the speaking world is reborn. Whoever goes to the bottom of reverie discovers natural reverie, a reverie of original cosmos and original dreamer. The world is no longer mute. Poetic reverie revives the world of original words. All the beings of the world begin to speak by the name they bear....

The Year After
Flash Art, Summer 1984

There is no such thing as East Village Art, as the various group shows or "cattle calls," as one curator critic referred to them, prove. There is, however, an exploding—correction, exploded—art scene. The eruption took place about a year ago; the few galleries already in existence started getting a lot of attention from collectors, press and museums. Art, too long repressed, exploded with savage energy.

The new season, starting in September 1983, brought a horde of ambitious entrepreneurs, most of them under thirty, eager to open spaces to deal and show art. Today, a year later, the key word is "deal," last year it was "show." The handful of galleries that existed a year ago continue to multiply; the current estimate is between twenty and thirty. The underground Bohemia of last year is now an all-out new establishment with all the intrigues that this engenders. The hawks are sweeping in; diplomacy and neo-arrivism confuse the counterculture. Artists' and dealers' ambitions lead to unspoken rivalries. It's the law of the jungle and the fittest survive.

The formation of cliques controls the process of natural selection inherent in a Bohemian underworld. It allows for mediocrity's laying an occasional claim, but ultimately quality prevails. Art in the East Village is perched in an interstice of time; the artist finds it necessary to exist on the edge of the edge if he or she is to avoid being swept along with the collective current. For this purpose the East Village is both dangerous and ideal. Ideal in that it could be an edge but dangerous because of its collective current.

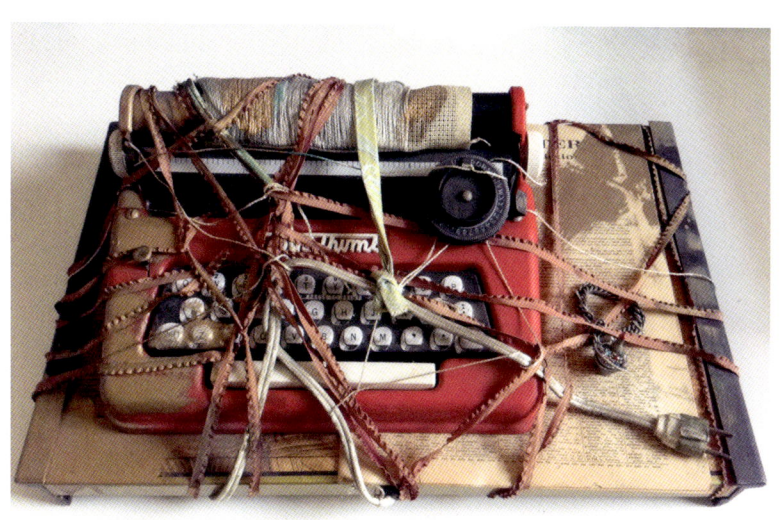

Eat Your Words, 1981–82. Mixed media and toy typewriter, offset print, ribbon, and embroidery on Warm-O-Matic serving tray, 11 x 16 x 6 inches. Collection of James H. Star. Photo by Sur Rodney (Sur)

His Embroidery Story
Sur Rodney (Sur)

In early spring 1981, I was introduced to Nicolas Moufarrege at a meeting arranged by my lover at the time, Andreas Senser. Andreas, who met Nicolas through mutual friends when they both were living in Paris, wanted him to view a group of artists I'd selected for a series of videotaped interviews I was producing as *The Sur Rodney (Sur) Show*. As a freelance journalist writing about art for the *New York Native*, Nicolas was interested in knowing more about all that was burgeoning as part of the "East Village scene." He hadn't known about my video project or the events related to it at the Mudd Club, but thanks to my status as lover he was perhaps more curious to talk to me than he might otherwise have been. Soon after this encounter, I left for London and Paris, where I would remain for months, while the pot of East Village stew began boiling over.

When I returned in the fall, the neighborhood was energized. Gracie Mansion had just rented and emptied out a hair salon, above a bar on St. Mark's Place, to accommodate her new gallery. Everyone seemed invigorated by what they were expecting to come out of all this. There was talk about a critic who wrote a piece for *Arts Magazine* that was going to blow up the scene. In the midst of the frenzy, the short, mustached man arrived, attracting a lot of attention. I watched how wittingly and gregariously he engaged his admirers. I was soon able to identify him; the humble man Andreas had introduced me to months earlier had found his legs. He was now part of a bevy of journalists, along with Rene Ricard, Cookie Mueller, Walter Robinson, Carlo McCormick, Kim Levin, Gary Indiana, and Yasmin Ramirez, among others, who would play a big part in promoting a new, viable art scene. Nicolas lent spirited and unexpected writing to this effort, but

we would also come to recognize that he had other concerns: he was also embroidering his fictions and exaggerated details into artworks.

One day, Nicolas dropped one off at the gallery for Gracie to sell. The object was a complex assemblage: a Warm-O-Matic serving tray supported a Tom Thumb toy typewriter and a greeting card inscribed with the message "We don't hear from you enough." The carriage of the typewriter held a piece of fabric with an unfinished embroidery. (The work foreshadowed his decision to give up writing to dedicate himself to embroidering.) Under the typewriter was a page from a Dennison *Webster's* dictionary, with definitions for the words *addict*, *addition*, *addle*, *address*, *adduce*, and *adduct*. The word *myth* ended the row of words partially concealed under the typewriter. Both typewriter and page were brushed with gold ink. A charm bracelet stapled to the tray held a miniature champagne bucket with semiprecious stones and a miniature bottle of champagne. Invisible from the top, a folded magazine page had been bound to the underside of the tray with the ribbons and fine gold and silver chains that also secured the typewriter to the top of the tray. The headlines read "Cleverest of Gifts for Gay Parties" and "Secret of Bright Parties," advertising a Toastmasters Party Guide available for mail order.

Gay and adventurous in his writing and his art making, Nicolas loved a bright party. Onto each of his artworks he would attach clever gifts of jewelry, and the attached jeweled gift to this artwork read "Eat Your Words." It was a declaration that let us know that there is always an occasion to celebrate—and, if not, make one. That's what writers and artists do.

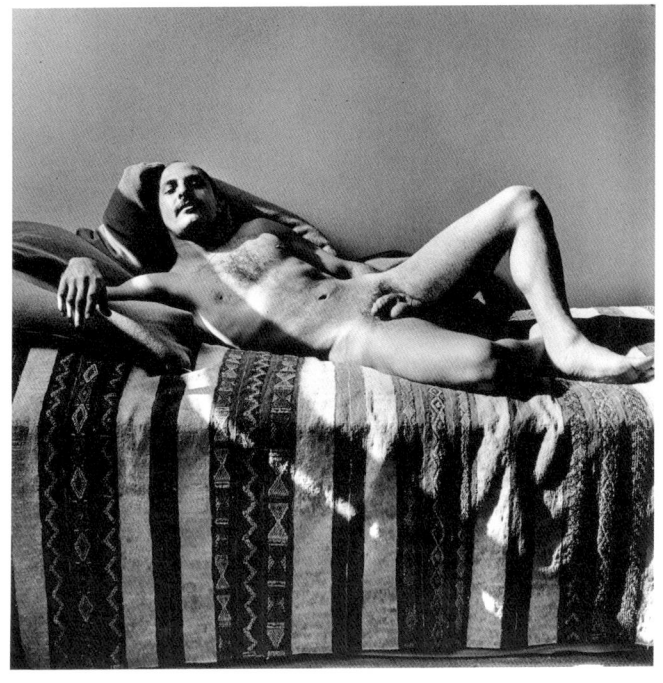

Peter Hujar, *Nicolas Abdallah Moufarrege, Paris*, 1980. Gelatin silver print, sheet size 20 x 16 inches.

Biography

Nicolas Abdallah Moufarrege (1947–1985) was an artist, art critic, and curator who was born in Alexandria, Egypt, to Lebanese parents. He received his BSc in 1966 and MSc in chemistry in 1968 at the American University of Beirut in Lebanon. He came to Cambridge, Massachusetts, in 1968 on a Fulbright grant and a Harvard University assistantship, before deciding to pursue a career in the arts.

Moufarrege spent the first half of the 1970s living in Beirut, until the beginning of the Lebanese Civil War in 1975, when he moved to Paris, living there through the second half of the decade. During this time, Moufarrege's art was shown in solo exhibitions at Triad Condas, Beirut (1973); "World of Islam Festival," Mathaf Gallery, London (1976); Galerie Kamp, Amsterdam (1977); George Zeeny Gallery, Beirut (1979); and "Trames Pantheistes," Galeries de Varenne (Jacques Damase), Paris (1980).

Moufarrege moved to New York City in 1981 and quickly became a central figure in the burgeoning East Village art scene. Writing for publications such as the *New York Native*, *Arts Magazine*, *Flash Art*, and *Artforum*, he was one of the earliest art critics to bring attention to upstart East Village galleries, such as FUN, Gracie Mansion, Civilian Warfare, and Nature Morte, among others. In his writing, Moufarrege highlighted the work of East Village denizens and emerging artists, including George Condo, Arch Connelly, Futura 2000, Keith Haring, Greer Lankton, Ann Magnuson, Chuck Nanney, Lucas Samaras, Kenny Scharf, David Wojnarowicz, and many others.

By the 1980s, Moufarrege's visual art most often used thread and paint on embroidery fabrics. From 1982 to 1984, Moufarrege had a studio at PS1, the Institute for Art and Urban Resources (now

MoMA PS1), through the International Studio Program. While at PS1, he had two studio exhibitions, "The New York Times Front Page" (1982) and "A Flag for the '80s" (1983). Moufarrege's first solo gallery exhibition in New York, "On Pins and Needles," took place at the Gabrielle Bryers Gallery in 1983. Two years later, he had a solo exhibition at the FUN Gallery on East Tenth Street.

 In 1987, Tim Greathouse, Cynthia Kuebel, Elaine Reichek, and Bill Stelling posthumously organized the largest exhibition of Moufarrege's work to date, at the Clocktower, the Institute for Art and Urban Resources, founded by Alanna Heiss. Since then, Moufarrege's work has been exhibited in group shows in New York, including "The Downtown Show" in 2006, curated by Carlo McCormick in consultation with Lynn Gumpert and Marvin J. Taylor at New York University's Grey Art Gallery, and "Side X Side" in 2008, curated by Dean Daderko for Visual AIDS at La MaMa Galleria.

 Moufarrege also curated exhibitions, often with allover salon-style displays. His 1983 exhibition "Intoxication" at Monique Knowlton Gallery in New York featured more than one hundred artists. His follow-up exhibition at Monique Knowlton Gallery, "Ecstasy" in 1984, featured twenty-five artists. "Correspondences: New York Art Now Exhibition," Moufarrege's final curatorial project, was an exhibition co-sponsored by the Japan–U.S. Friendship Commission featuring ninety-three artists. The exhibition opened after Moufarrege's passing at the Laforet Museum Harajuku, Tokyo (1985–86), and the Tochigi Prefectural Museum of Fine Arts, Utsunomiya (1986).

 Moufarrege died at age thirty-seven of AIDS-related complications on Tuesday, June 4, 1985, at the North Central Bronx Hospital in New York. He is survived by his sister, Gulnar (Nouna) Mufarrij, and brother, Nabil Moufarrej, and his family, in Shreveport, Louisiana.

Bibliography

Selected Writings by Nicolas A. Moufarrege

"Art, Myth and Grammar: Symbol, Sign and Nature." *Natura Integrale*, November 1980.

"Neo-Classics (and Other Icons)." *New York Native,* December 21, 1980–January 3, 1981, 25.

"Restaurants." *New York Native,* June 29–July 12, 1981, 37.

"Qwik Art or Descartes?" *New York Native*, March 1–13, 1982, 26.

"Dada, Dominos, and DeMillions." *New York Native,* May 10–23, 1982, 30.

"Arty, Party, Smarty." *New York Native*, June 7–20, 1982, 35.

"The Best Worst Art." *New York Native,* July 5–18, 1982, 26.

"Ambisexual Art." *New York Native*, August 2–15, 1982, 29.

"Camp David." *New York Native,* August 20–September 2, 1982, 36.

"Another Wave, Still More Savagely Than the First: Lower East Side, 1982." *Arts Magazine* 57, no. 1 (September 1982): 69–73.

"Candy Darling: Oceans of Love . . . / Christopher Makos." *Arts Magazine* 57, no. 1 (September 1982): 31.

"Janis Provisor." *Arts Magazine* 57, no. 1 (September 1982): 31.

"Terry Rosenberg." *Arts Magazine* 57, no. 1 (September 1982): 31.

"Philip Smith." *Arts Magazine* 57, no. 1 (September 1982): 31.

"Extended Anger." *New York Native,* September 27–October 10, 1982, 34.

"Bernard Faucon: Summer Camp." *Arts Magazine* 57, no. 2 (October 1982): 5.

"Group Show." *Arts Magazine* 57, no. 2 (October 1982): 19.

"Lavender: On Homosexuality and Art." *Arts Magazine* 57, no. 2 (October 1982): 78-87.

"Gina Wendkos and George Dudley: Blue Blood." *Arts Magazine* 57, no. 2 (October 1982): 19.

"Extended Icons." *New York Native,* October 11-24, 1982, 34.

"George Dudley." *Arts Magazine* 57, no. 3 (November 1982): 15.

"The Erotic Impulse." *Arts Magazine* 57, no. 3 (November 1982): 5-6.

"Lighting Strikes (Not Once but Twice): An Interview with Graffiti Artists." *Arts Magazine* 57, no. 3 (November 1982): 87-93.

"The State of New York Art." *GQ,* December 1982, 56.

"The Famous Show." *Flash Art*, no. 110 (January 1983): 62-63.

"X Equals Zero, as in Tic-Tac-Toe." *Arts Magazine* 57, no. 6 (February 1983): 116-21.

"East Village." *Flash Art*, no. 111 (March 1983): 36-41.

"Found Objects and Found Space." *New York Native*, March 14-27, 1983, 29.

"Intoxication: April 9, 1983." *Arts Magazine* 57, no. 8 (April 1983): 70-76.

"Face a Face: Dust, Spit, and Thread: The Pastels of Lucas Samaras." *Arts Magazine* 57, no. 9 (May 1983): 74-77.

"Tseng Kwong Chi and Rammellzee." *Flash Art*, no. 112 (May 1983): 61-62.

"The Mutant International." *Arts Magazine* 58, no. 1 (September 1983): 120-25.

"The Mutant International; II: The Still-Life Victims of the Painter of a Thousand Perils." *Arts Magazine* 58, no. 2 (October 1983): 57-61.

"The Mutant International; III: The Last Star . . . Aurora." *Arts Magazine* 58, no. 3 (November 1983): 85-89.

"The Mutant International; IV: My Heart Laid Bare . . . Green Blood."

Arts Magazine 58, no. 4 (December 1983): 124–28.

"The Mutant International; V: Now Playing Everywhere." *Arts Magazine* 58, no. 5 (January 1984): 134–37.

"James Rosenquist." *Flash Art*, no. 115 (January 1984): 36.

"The Mutant International; VI: 'En Gifles Majuscules!!**!?'" *Arts Magazine* 58, no. 6 (February 1984): 77–79.

"The Mutant International; VII: Time and Timing, Shelter and Storm." *Arts Magazine* 58, no. 7 (March 1984): 62–64.

"Jay Coogan, Monique Knowlton Gallery, New York; exhibit." *Flash Art*, no. 117 (April 1984): 36–37.

"Guy Augeri, Phyllis Kind Gallery, New York; exhibit." *Flash Art*, no. 118 (Summer 1984): 69.

"Kenny Scharf, Tony Shafrazi Gallery, FUN Gallery, New York; exhibit." *Flash Art*, no. 118 (Summer 1984): 68.

"The Year After." *Flash Art*, no. 118 (Summer 1984): 51–55.

"Jean-Michel Basquiat, Boone/Werner Gallery, New York; exhibit." *Flash Art*, no. 119 (November 1984): 41.

"James Nares, Cable Gallery, New York; exhibit." *Flash Art*, no. 119 (November 1984): 42.

"An International Survey of Recent Painting and Sculpture." *Artforum* 23, no. 4 (December 1984): 3.

"London in the Thirties." *Artforum* 23, no. 4 (December 1984): 78.

"The Sexuality of Christ in Renaissance Art and in Modern Oblivion." *Artforum* 23, no. 4 (December 1984): 76.

"Untitled '84: The Artworld in the Eighties." *Artforum* 23, no. 4 (December 1984): 74.

"Zush, Phyllis Kind Gallery, New York; exhibit." *Flash Art*, no. 120 (January 1985): 43.

"George Condo, Barbara Gladstone Gallery; Pat Hearn Gallery, New York; exhibit." *Flash Art*, no. 121 (March 1985): 43.

Contributors

Dean Daderko is curator at the Contemporary Arts Museum Houston. His recent exhibitions include "Double Life" (2015); "LaToya Ruby Frazier: Witness" (2014), which traveled to the Institute of Contemporary Art, Boston; and "Parallel Practices: Joan Jonas and Gina Pane" (2013). In 2008, Daderko guest-curated "Side X Side" for Visual AIDS at La MaMa Galleria, an exhibition that included paintings by Nicholas Moufarrege, alongside works by Scott Burton, Kate Huh, Martin Wong, and Carrie Yamaoka.

Elaine Reichek is an artist based in New York. She has exhibited extensively in the United States and abroad for more than forty years, including solo shows at New York's Museum of Modern Art and the Jewish Museum; Palais des Beaux-Arts, Brussels; Tel Aviv Museum; Stichting De Appel, Amsterdam; and the Irish Museum of Modern Art, Dublin. Her work is in the collections of New York's Museum of Modern Art, the Jewish Museum, and the Whitney Museum of American Art; the Museum of Fine Arts, Boston; Pennsylvania Academy of the Fine Arts Museum, Philadelphia; and the Irish Museum of Modern Art in Dublin, among many others. Her most recent solo exhibitions include "Minoan Girls" at Shoshana Wayne Gallery, Santa Monica (2016), and "Swatches" at Zach Feuer Gallery, New York (2015).

LJ Roberts is a visual artist who creates large-scale textile installations, detailed embroideries, screen prints, and collages. Their work investigates overlaps of queer and trans politics, activism, protest, and craft through an intersectional feminist lens. LJ's work

has been shown in the United States, the United Kingdom, Canada, South Africa, and Australia at such venues as the Victoria and Albert Museum, London; Yerba Buena Center of the Arts, San Francisco; Orange County Museum of Art, Newport Beach, California; the Bag Factory, Johannesburg; the Leslie-Lohman Museum of Gay and Lesbian Art, New York; and the Smithsonian Museum of American Art, Washington, DC, where their work is in the permanent collection. Current projects include a collaged embroidered opus made with collaborator Kate Huh that debuted at the ONE National Gay and Lesbian Archives at the University of Southern California in spring 2016, as well as a sex-positive women-centered safer sex packet in collaboration with Visual AIDS for the exhibition *Agitprop!* at the Brooklyn Museum.

Sur Rodney (Sur) is an archivist, writer, and curator. As codirector of the Gracie Mansion Gallery from 1983 to 1988, he cultivated a host of young and emerging artists to international recognition and acclaim. (Sur) is an important voice in the arts scene for raising awareness about the AIDS crisis, helping to establish the Frank Moore Archive Project of Visual AIDS and serving on the Visual AIDS board for more than a decade. As a curator, he has collaborated with his longtime partner Geoffrey Hendricks on a series of projects and exhibitions relating to art and AIDS. He recently contributed to the exhibition catalogue *Art AIDS America*, organized by the Tacoma Art Museum, in partnership with the Bronx Museum of the Arts.

Series edited by Nelson Cantoo, Visual AIDS
Edited by Barbara Schröder and Karen Kelly of Dancing Foxes Press and Alex Fialho of Visual AIDS
Book design by Tiffany Malakooti
Proofreading by Sam Frank
Factchecking by Yanhan Peng
Printed and bound by die Keure, Brugge, Belgium

This book is typeset in Antique Olive, Atlas Grotesk, Lyon and printed on Magno Matt Classic 135 gsm.

Published by Visual AIDS, New York

Visual AIDS is the only contemporary arts organization fully committed to HIV prevention and AIDS awareness through producing and presenting visual art projects, while assisting artists living with HIV/AIDS. We are committed to preserving and honoring the work of artists with HIV/AIDS and the artistic contributions of the AIDS movement.

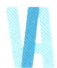

Visual AIDS
526 West 26th Street #510, New York, NY 10001
P: 212.627.9855
E: info@visualaids.org

ISBN: 978-0-9678425-0-9

© 2016 Visual AIDS, New York
All rights reserved. No part of this publication may be reproduced or transmitted in any form or by any means, electronic or mechanical, including photocopy, recording, any other information storage and retrieval system, or otherwise without written permission from the publisher.

Unless otherwise indicated, all artwork © Estate of Nicolas Moufarrege

Cover: Title unknown (detail), nd. Thread and paint on needlepoint canvas, 49⅞ x 64 inches. Collection of Nabil A. Moufarrej (page 35)

Photo credits: cover, pp. 6, 8, 14, 18–19, 21, 22, 25, 28–29, 30, 31, 34, 35, 36, 37, 40, 41, 44, and 47: photos by Neil Johnson; p. 5: courtesy of the Estate of Nicolas Moufarrege; pp. 10 and 42: photos by Christopher Burke Studio; p. 26: photo by Lorin Bowen; p. 27: courtesy of the artist and Feuer/Mesler, New York, photo by Christopher Burke Studios; p. 38: digital image © The Museum of Modern Art/Licensed by SCALA/Art Resource, NY; p. 45: photo by Tim Cone; p. 49: courtesy Dirk Rowntree; p. 61: photo by Sur Rodney (Sur); p. 64: © 1987 The Peter Hujar Archive LLC; courtesy Pace/MacGill Gallery, New York and Fraenkel Gallery, San Francisco

Printed in Belgium